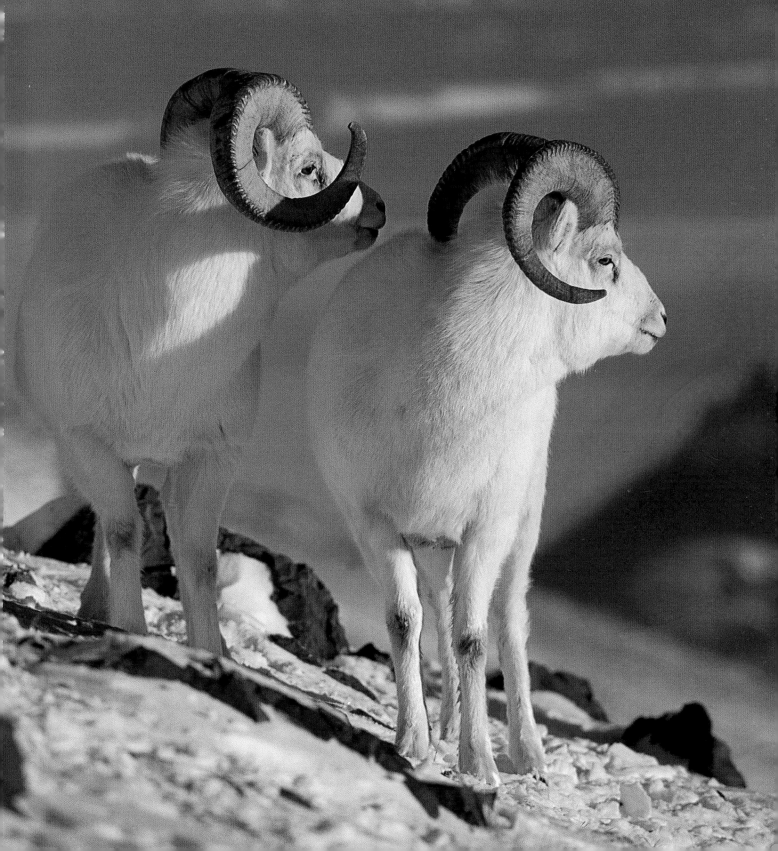

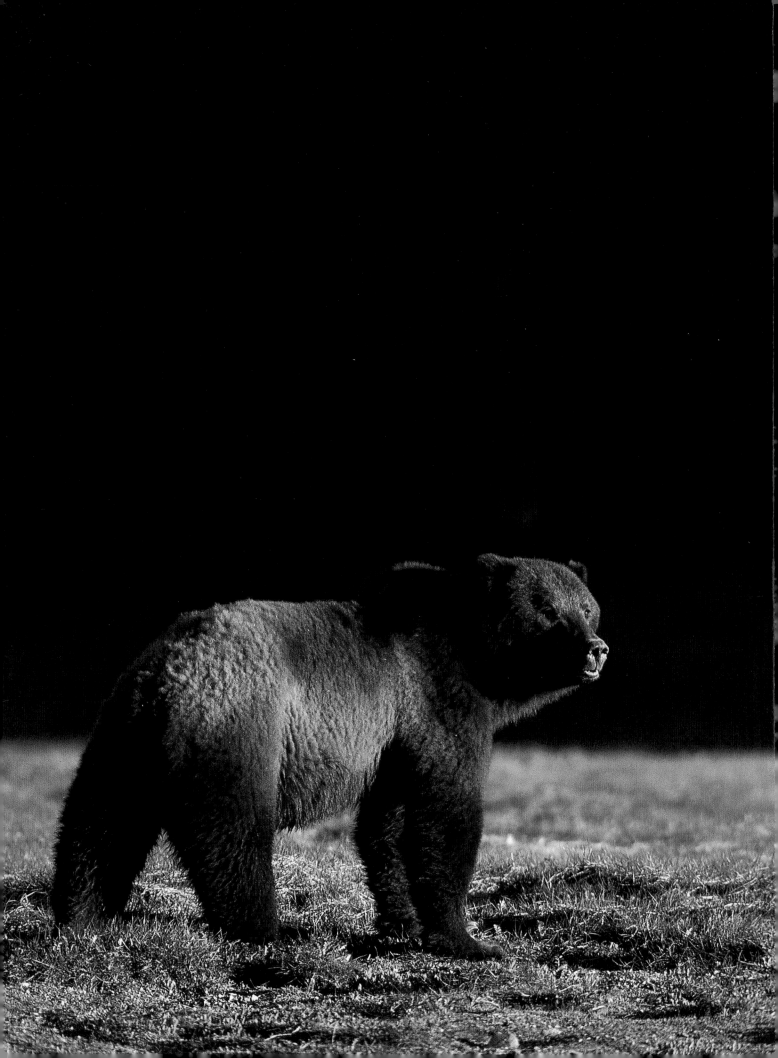

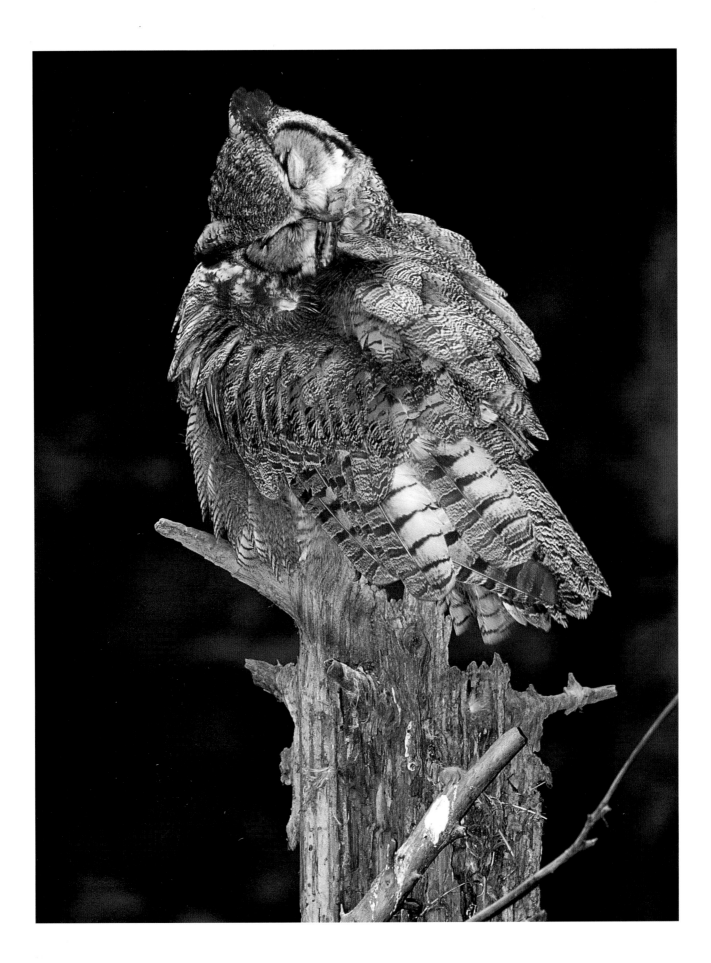

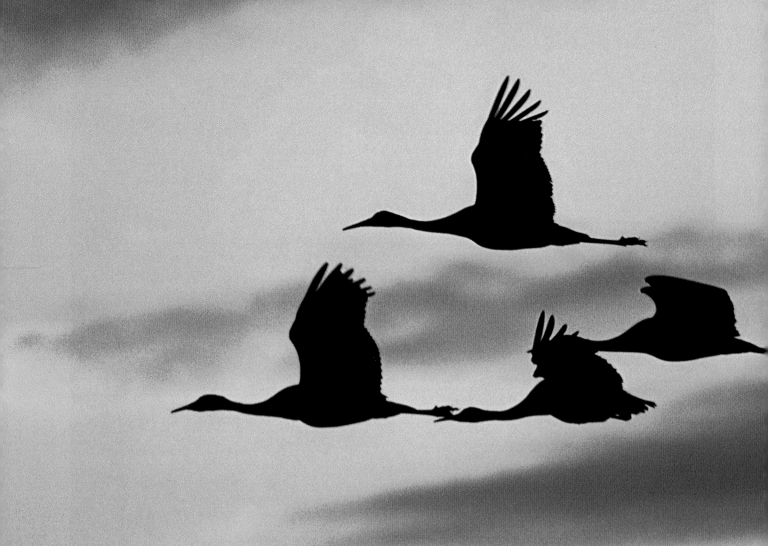

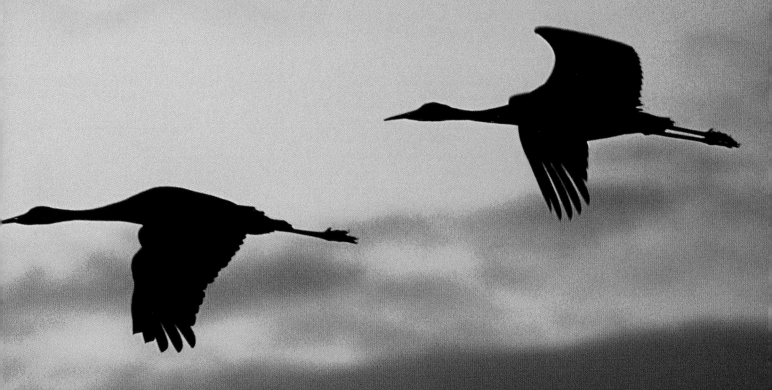

PORTRAIT OF
ALASKA'S
WILDLIFE

Photographs & Text by
TOM WALKER

GRAPHIC ARTS CENTER PUBLISHING®

International Standard Book Number 1-55868-364-X
Library of Congress Catalog Number 97-73083
Text and photographs © MCMXCVII by Tom Walker
Compilation of photographs © MCMXCVII by
Graphic Arts Center Publishing Company
P.O. Box 10306 • Portland, Oregon 97296-0306 • 503/226-2402
President • Charles M. Hopkins
Editor-in-Chief • Douglas A. Pfeiffer
Project Editor • Jean Andrews
Photo Editor • Diana S. Eilers
Production Manager • Richard L. Owsiany
Book Manufacturing • Lincoln & Allen Company
Printed in the United States of America

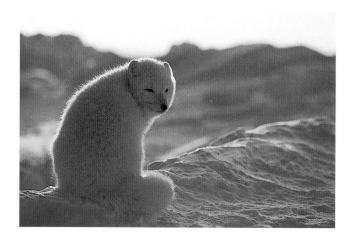

Front cover: *Caribou swim during migration or to escape predators.*
Back cover: *A two-year-old brown bear cub maintains an alert watch.*
Page 1: *Hollow hairs and layers of fat keep Dall sheep rams warm.*
Page 2: *On Admiralty Island, a brown bear forages on sedges.*
Page 3: *Great horned owls are nocturnal, sleeping much of the day.*
Title Page: *Lesser sandhill cranes fly over the Delta/George Lake area.*
▲ *The arctic fox's white winter coat provides perfect camouflage.*
► *A bear's thick fur and fat offer protection from the arctic cold.*

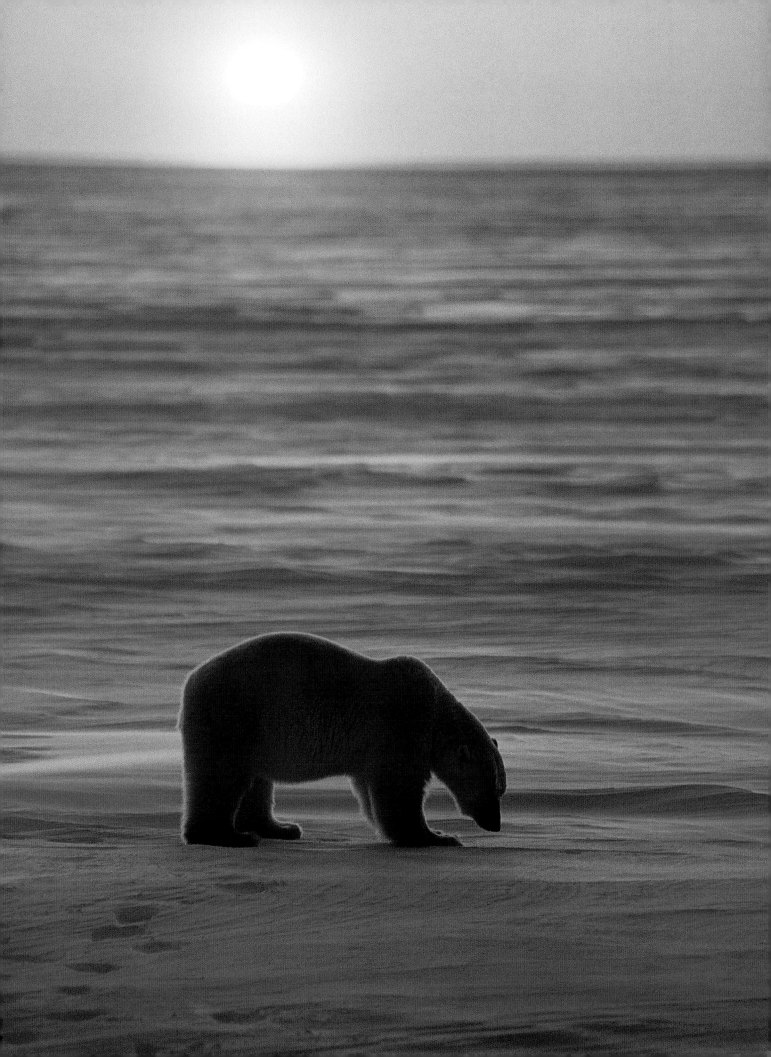

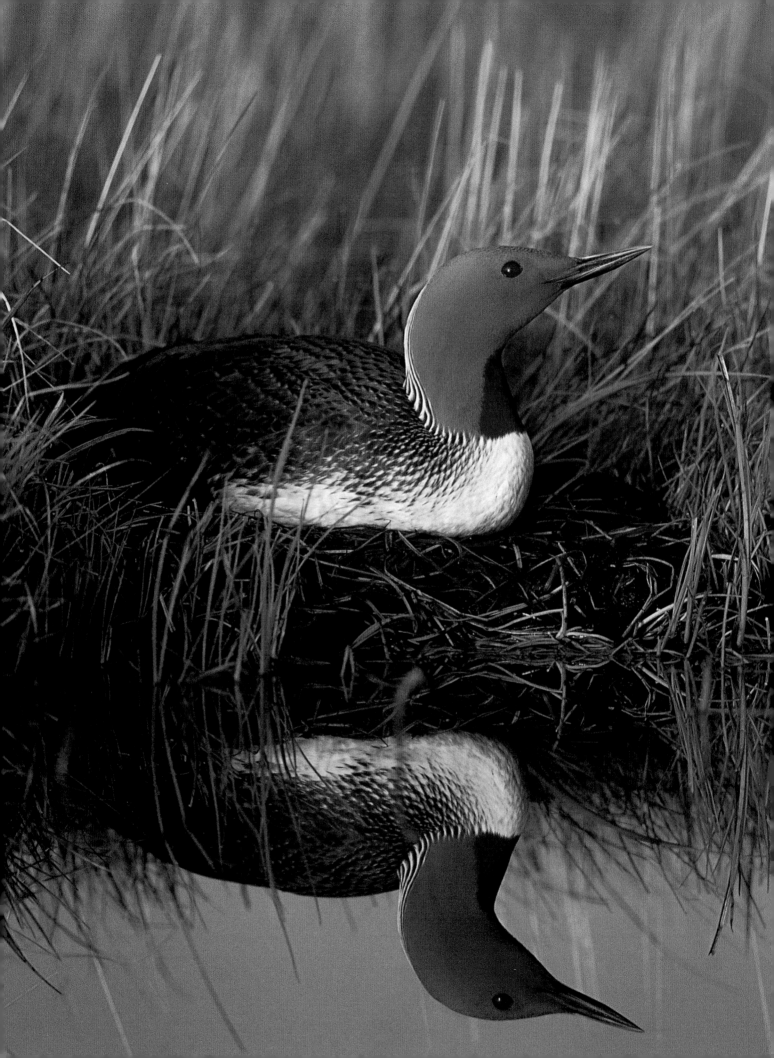

arctic loons & wolverines

The reality of wildlife photography is far different from popular perceptions. Upon viewing my photograph of a nesting red-throated loon, a woman remarked that she would love to have been there. I asked her to articulate the imagined circumstance. She described herself on a warm summer evening in a blind by the side of a tranquil pond enjoying the varied loon behaviors. When she finished her description, I could only wish that outdoor photography in Alaska were as pleasant as her conception.

To get that picture, I had waited for days, not just hours. The wind blew across the tundra day after day without letup. Cold, snowy days alternated with sunny, warm ones filled with mosquito legions that turned the inside of the blind into a Dantesque hell. My food ran low, and I suffered from a miserable flu-like illness that kept me in my tent for three days. When the wind finally died one night, at about 2 A.M., it did so for only two or three hours. The sky was clear; the arctic sun, unobscured. As the wind faded and the water stilled, the loon dozed. Expecting the wind to pick up at any time, my tension level increased by the moment. Warm light, golden grass, a gorgeous bird, a marvelous reflection in the water. If only the bird would open its eyes, look alert.

Then it happened: an arctic fox sallied across the marsh. The loon's head popped up, eyes sparkling with a striking catch light, its head swiveling to follow the meandering fox. Once the fox passed by, the loon stirred and rose up to roll its eggs around before settling on them again. In those few moments, I forgot the cold, my fatigue, and the mosquitoes. Within an hour, the wind again began to blow, and the reflection disappeared in the roiled water.

Wildlife photography in true wilderness is often uncomfortable, and not without hazard. In reality, wildlife—bears, for example—pose the least risk to the photographer. Stream-crossings, boat and small plane transportation, storms, isolation, injury, hypothermia—all offer greater risk. At best, wildlife photography often means camping for days at a time in small tents and subsisting on almost unpalatable, freeze-dried foods. It requires rigorous hiking across difficult terrain, while burdened under the weight of an enormous pack full of absurdly expensive, high-tech equipment that must be protected from impact damage and the assault of the elements. Even good days usually mean being cold, tired, and hungry. Most of all, the craft requires more patience than was allotted to Job. Wildlife photography can be described as hours and hours of boredom interspersed with brief moments of joy.

Then why do it? Great wildlife photographers are often described as driven—or obsessed. And so it appears. I prefer, however, to think that most of us do what we do because we possess tremendous imaginations. We fantasize endlessly, imagining the perfect picture, or what lies around the next bend in the river. I could see in my mind's eye, for example, the loon picture well before the elements came together. No matter how pie-in-the-sky, I envision scenes I want to photograph: a black bear with a bright red salmon in its mouth; wolves pulling down a moose; a wolverine digging squirrels. Whenever my enthusiasm is squashed by physical toil, bad weather, or short rations, all I need is to get a glimpse of a prized subject and I'm off, ready to try again.

Some dreams are elusive. Over time, I have seen fourteen different wolverines roaming wild and free but have yet to get a picture of one. Other dreams come true with remarkable alacrity. Once, while sitting on a hillside in the Brooks Range enjoying the view of snow-capped Mount Chamberlin, I thought, *If only a herd of caribou would come into sight now.* Less than half an hour later, a herd of caribou trotted over the ridge precisely where desired.

In winter, I often daydream of photographing a moose or caribou on a scarlet sward, or against a backdrop of golden hills dominated by snow-tipped peaks. I am awakened at night by images of thousand-pound bull moose jousting with one another, or of bears going at it with gaping jaws and swatting paws. Unlike many events in dreams, these visions are the residue of reality. Perhaps the one single reason why I persist, despite the hardships and solitude, is because, in the end, through the lens, dreams do come true.

◄ *To attain flight, loons must first run a considerable distance across the water. Red-throated loons fly after a short run, which allows the use of small nesting ponds.*

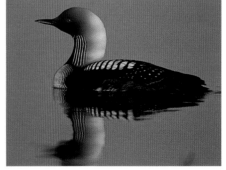

Pacific loon

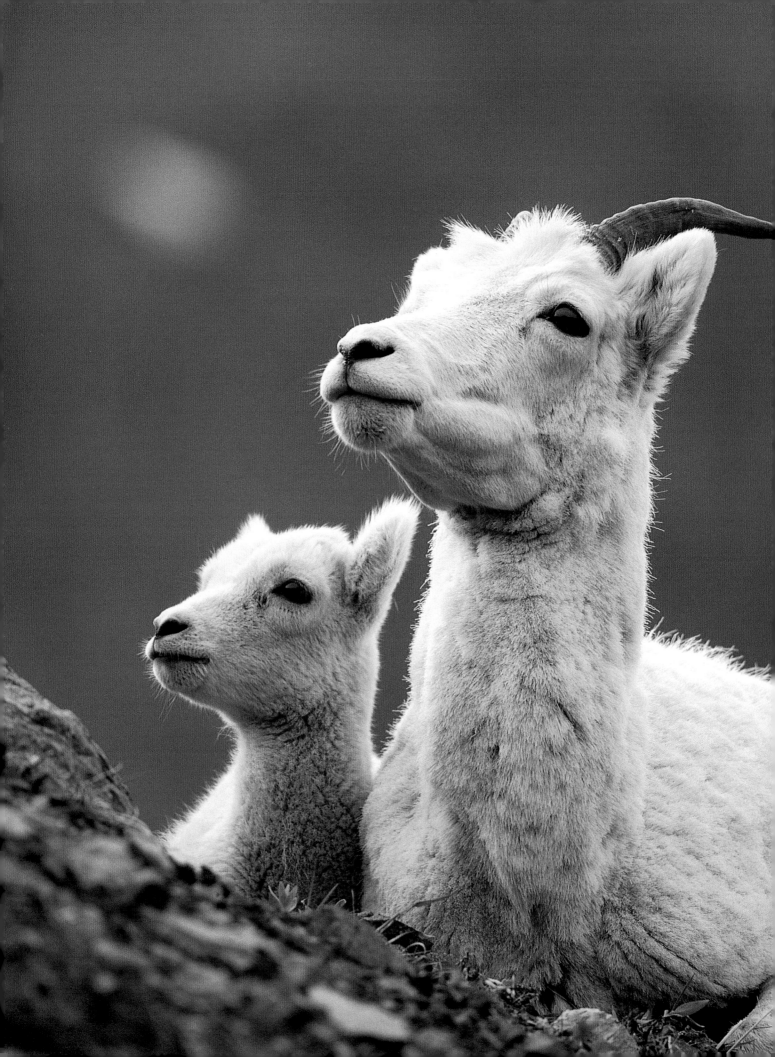

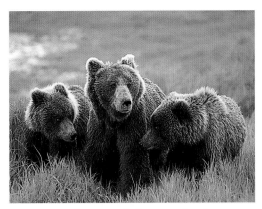

Mother grizzly bear and cubs

calves, cubs & wolf pups

Spring is a time of challenge, a time of renewal. Reluctantly, winter eases its grip on the land. One day it is snowing and cold; the next, sunny and mild. Each day the sun rises higher in the sky and stays longer. Many animals, their reserves of energy and strength depleted, totter on the brink of survival. Late winter storms kill many adults as well as newborns. At last, the sun defeats the snow and cold. Willow buds emerge, and life-giving shoots nudge through the warming soil. New growth banishes malnutrition.

Increasing daylight triggers pelage and plumage changes in animals that vary in color; encourages migrations of birds, fish, and mammals; and stirs hibernators. Weasels, hares, ptarmigans, collared lemmings, and arctic foxes begin to turn from white to brown. Birds arrive from as far away as Africa and Antarctica, waterfowl wing toward arctic nesting grounds, and millions of shorebirds gather on tidal flats. Bears, marmots, and ground squirrels blink in the sun after long winter sleeps. Moose calves wobble in spruce thickets, Dall lambs traverse rocky cliffs, and bear cubs follow their mothers across the tundra. Timing is crucial. Birthing and hatching are concentrated, both to foil predators and to take best advantage of the short, four-month growing season. Foxes, coyotes, wolves, and lynx raise litters. Owls, hawks, and eagles feed nestlings. Spring, the beginning of the brief respite from winter, has begun.

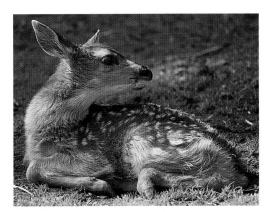

Sitka black-tailed deer fawn

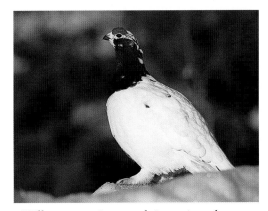

Willow ptarmigan cock in spring plumage

◄ *A female lamb will likely live out its life near its mother and in the band of its birth. Ewes and lambs live most of the year apart from mature rams, the sexes mingling during the fall rut.* ►► *Moose wade into and feed on aquatic plants of lakes in view of Denali, "the high one."*

11

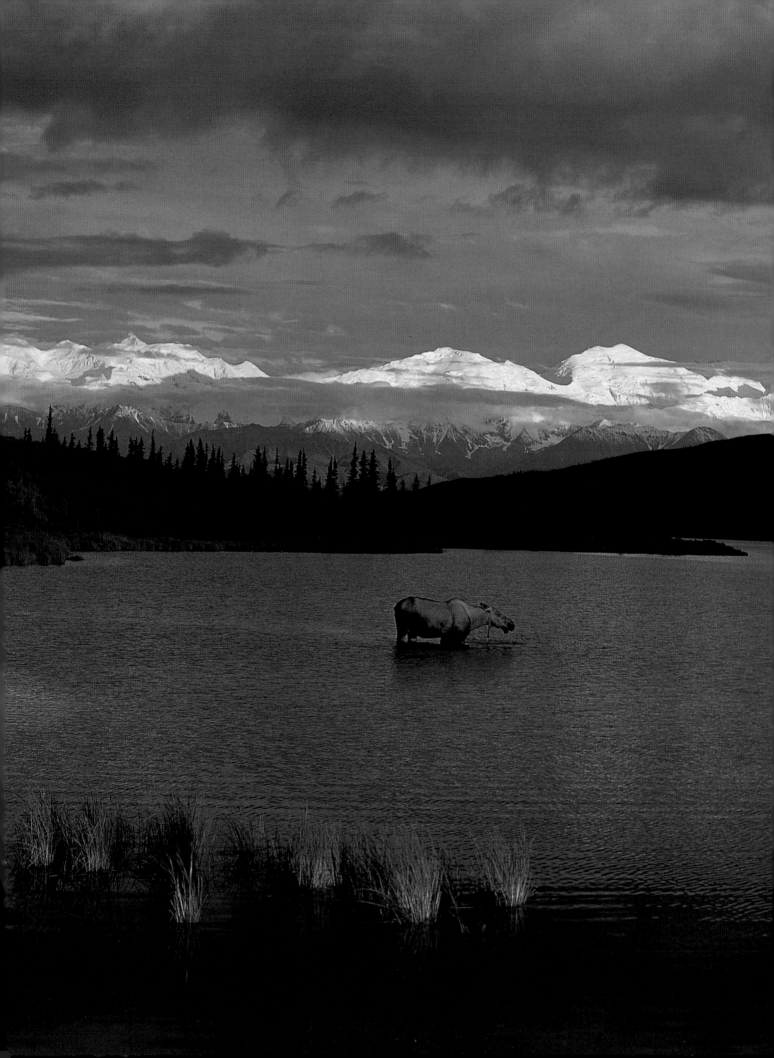

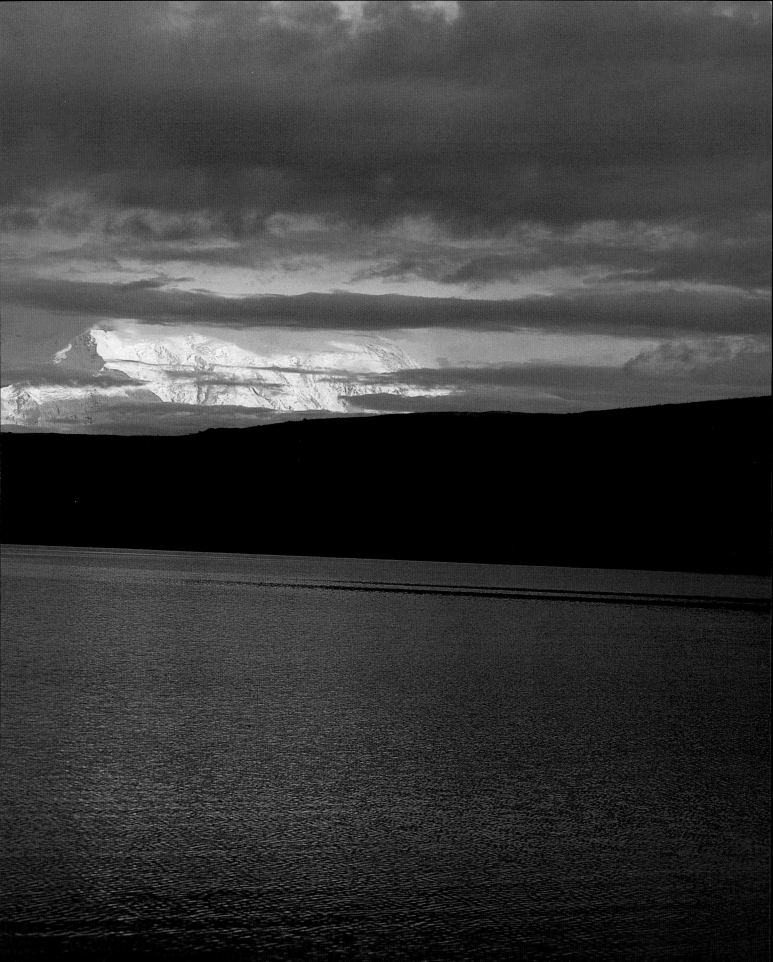

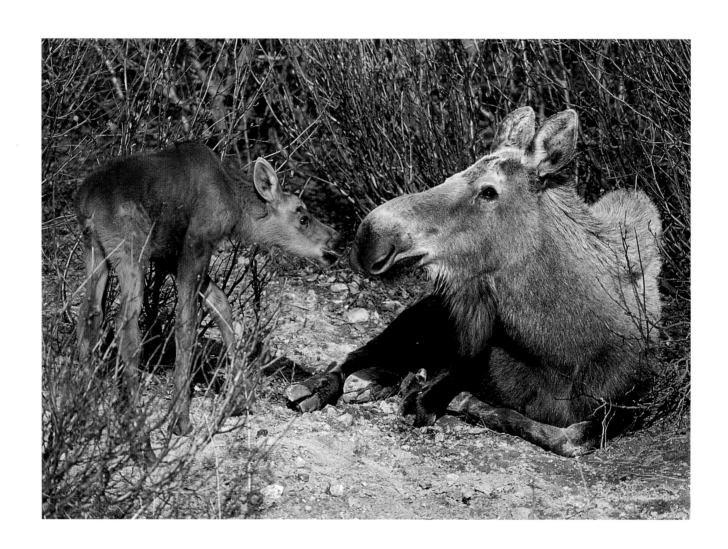

▲ *Calf moose are born from mid-May to early June. Twinning is common; triplets are not. Multiple births indicate good quality of habitat. Calves weigh about thirty-five pounds at birth and grow quickly, weighing over three hundred pounds by winter. Cow moose vigorously protect their calves from black bears, wolves, and humans.*

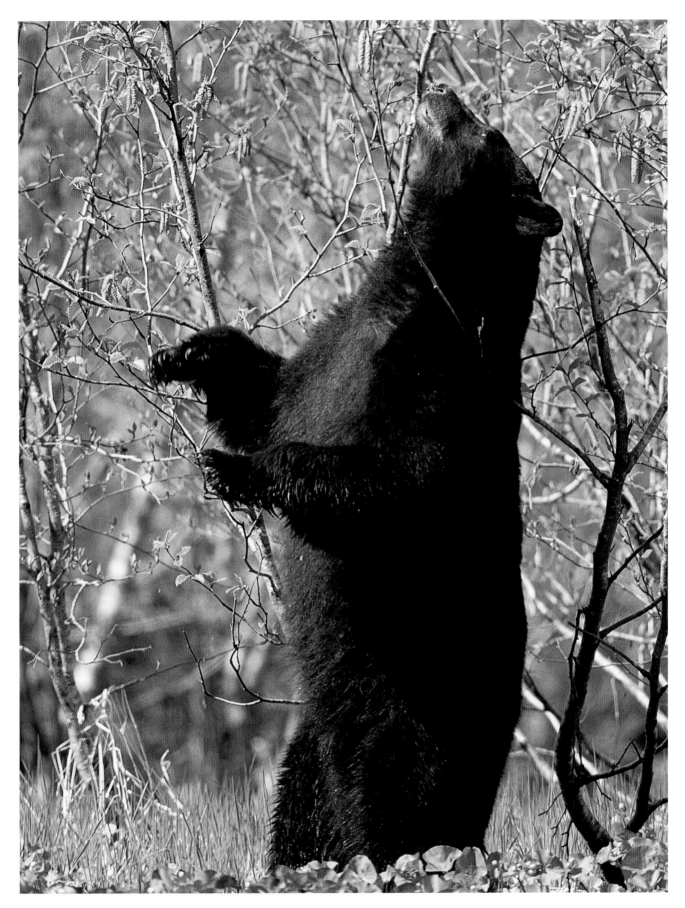

▲ *In some areas, such as the Kenai Peninsula, black bears prey on moose calves in spring. Bears scent-mark alders by walking over them or standing to rub against and bite them, behavior that is sometimes preceded by stylized pacing.*

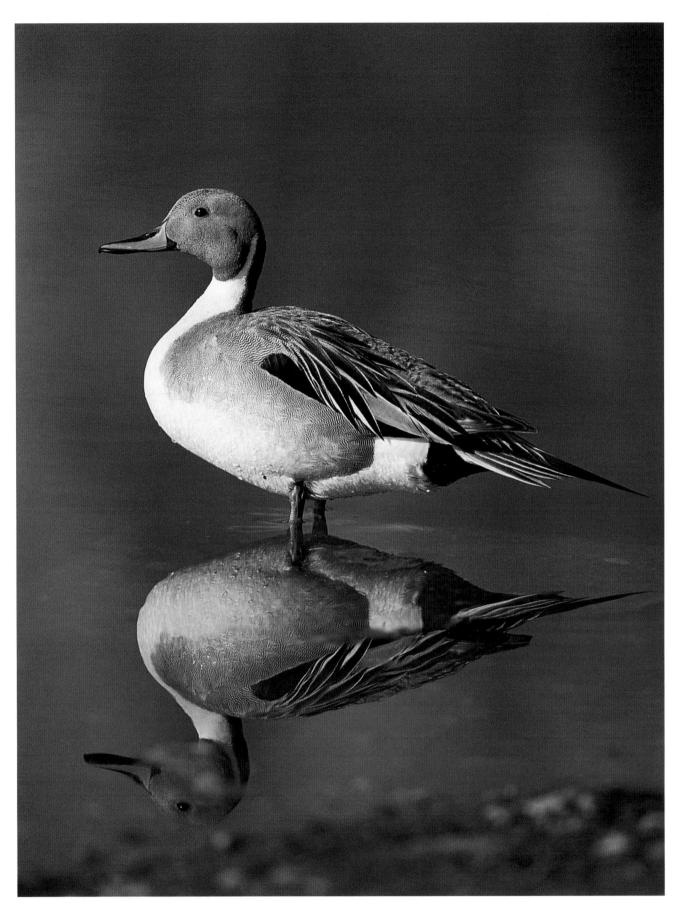

▲ *Northern pintails, Alaska's most abundant puddle duck, travel at speeds up to sixty-five miles per hour. They reach under water for seeds, plants, and aquatic invertebrates. Females lay eggs in concealed nests, at times away from water.*

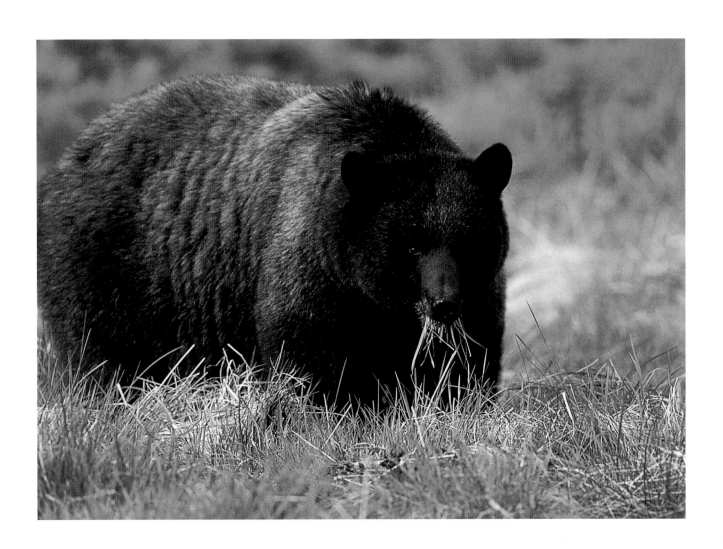

▲ *Some black bears are actually blue in color and are often called glacier bears. Glacier bears,* Ursus americanus, *are found only in Southeast Alaska, and nowhere are they numerous. One estimate places the population there at no more than one percent of the total black bear population. All bears graze spring sedges when available.*

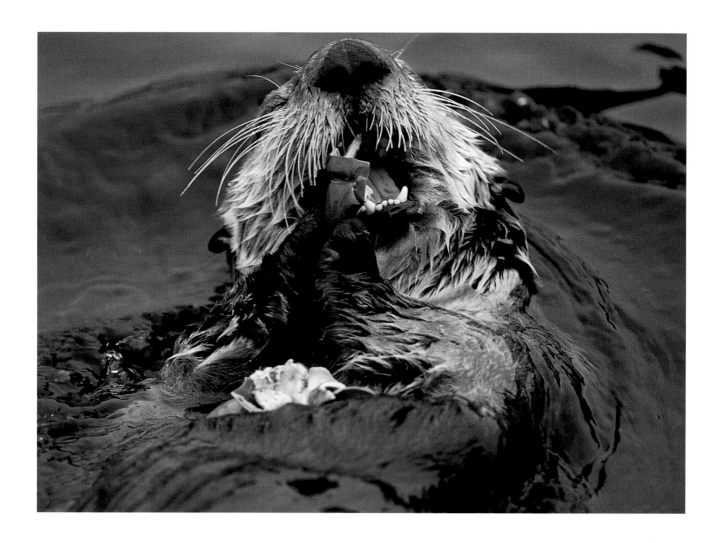

▲ *Sea otters eat up to 25 percent of their body weight daily; males weigh up to one hundred pounds. These members of the weasel family prey on fish, mollusks, crustaceans, and octopi.* ▶ *Bald eagles, and rarely golden eagles, perch on ice to watch for prey: primarily fish, but also ducks, seabirds, and newborn seals.* ▶▶ *Female brown bears protect their cubs by moving away when other bears approach or appear. Open areas offer unhindered viewing and decrease chances for surprise encounters.*

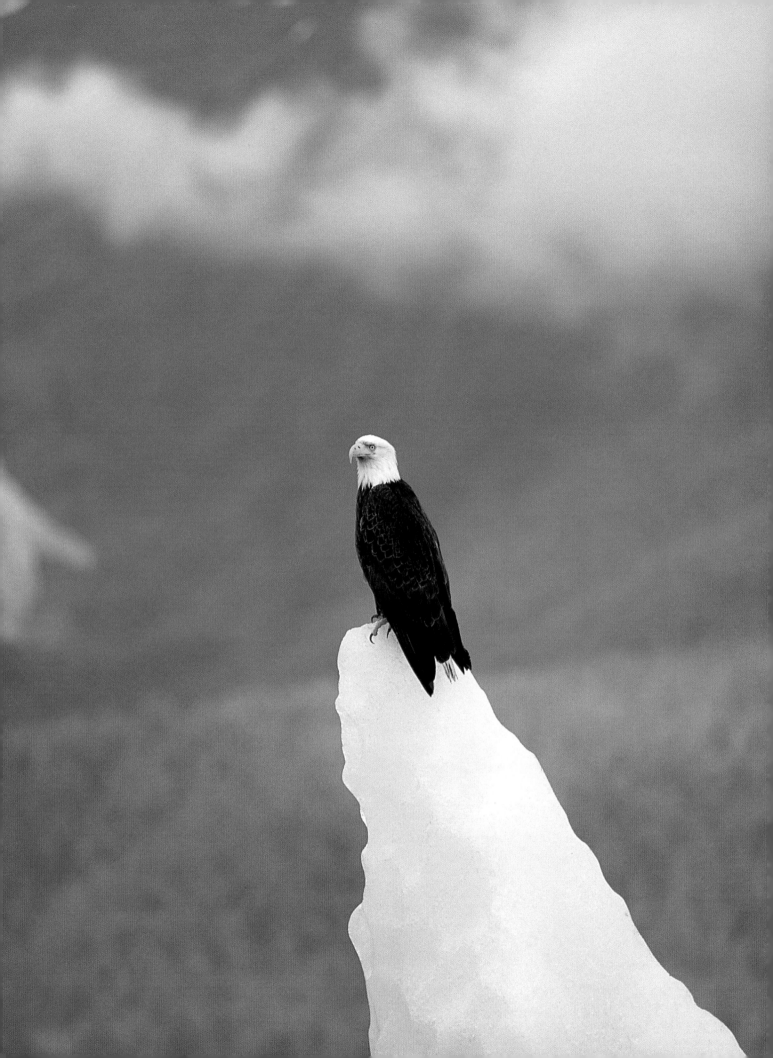

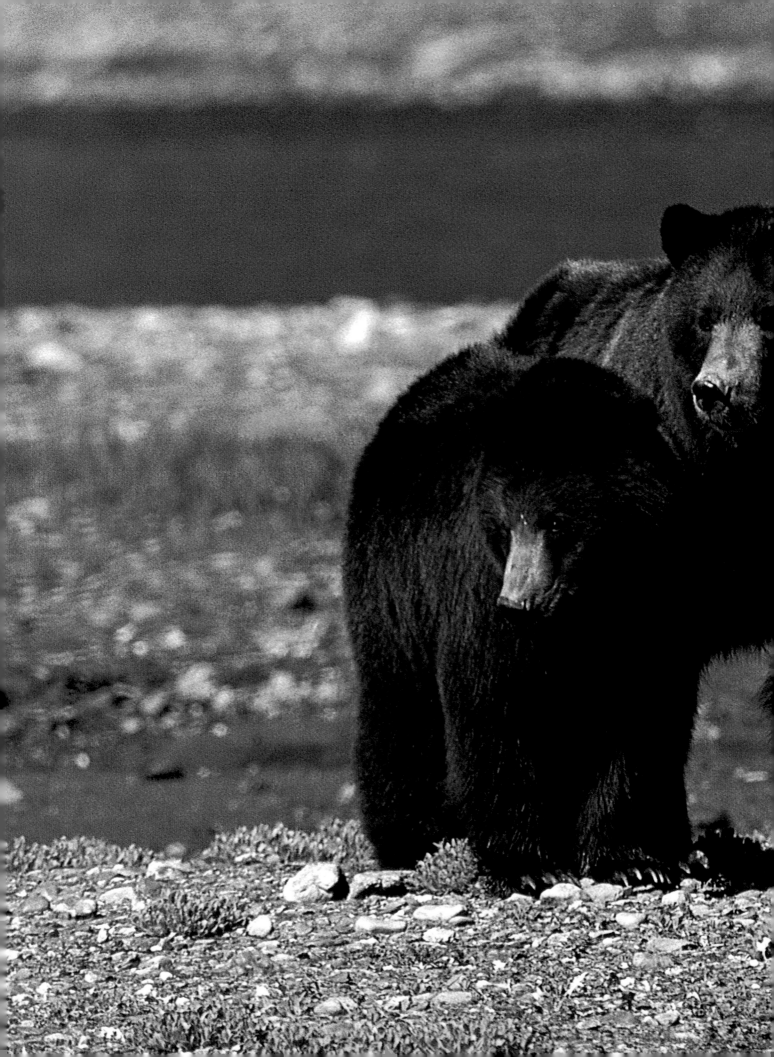

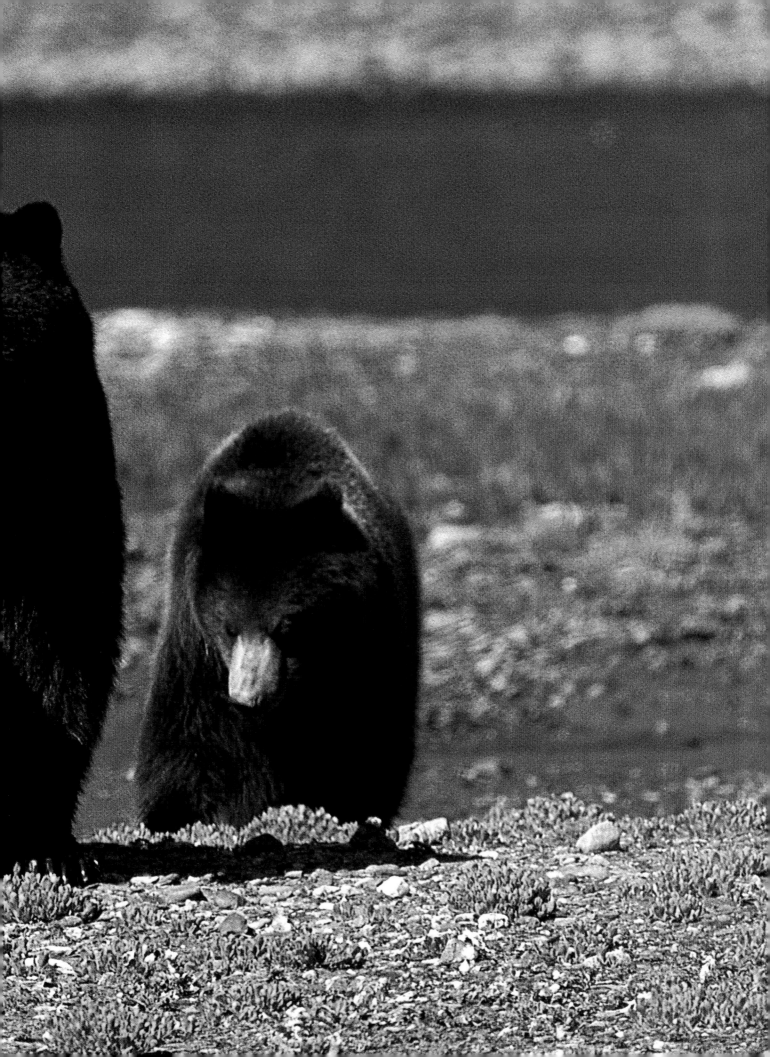

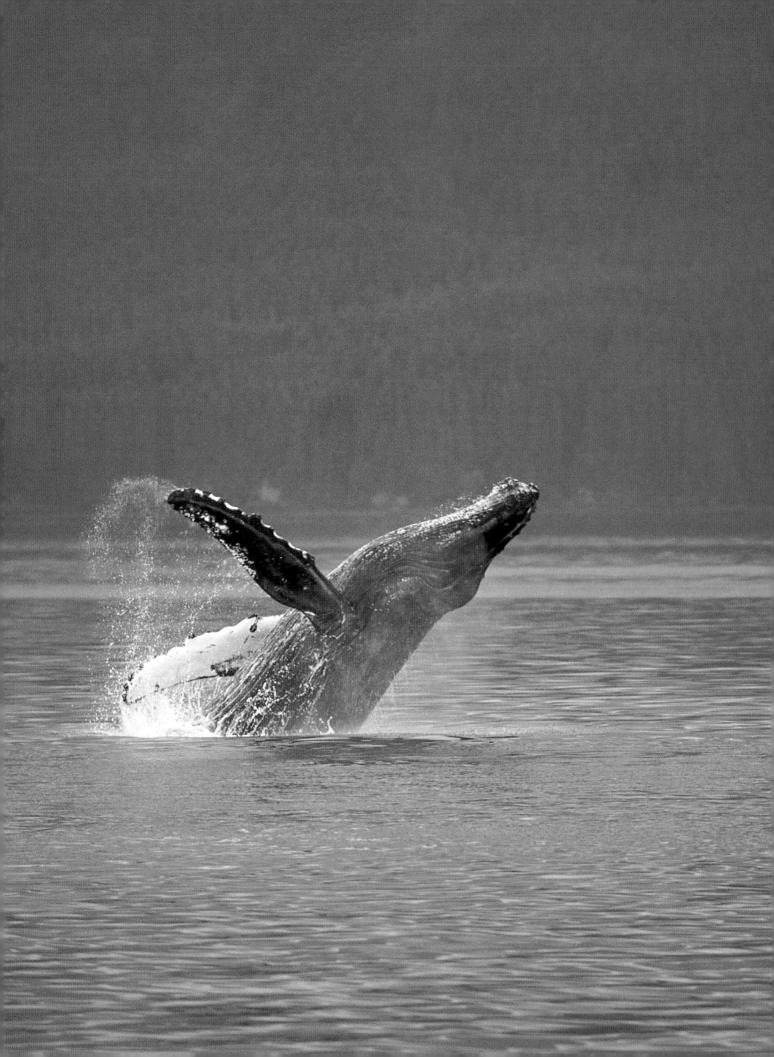

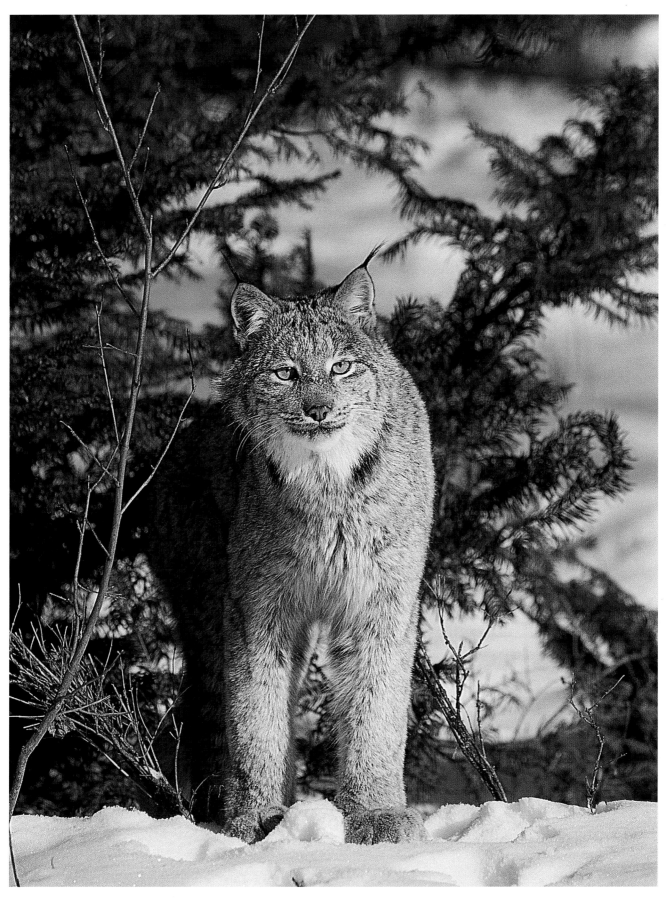

◄ *Endangered humpback whales migrate in spring from Hawaiian waters to Southeast Alaska's rich feeding grounds.* ▲ *Normally active at night, lynx are sometimes seen in early mornings of late March when they search for mates.*

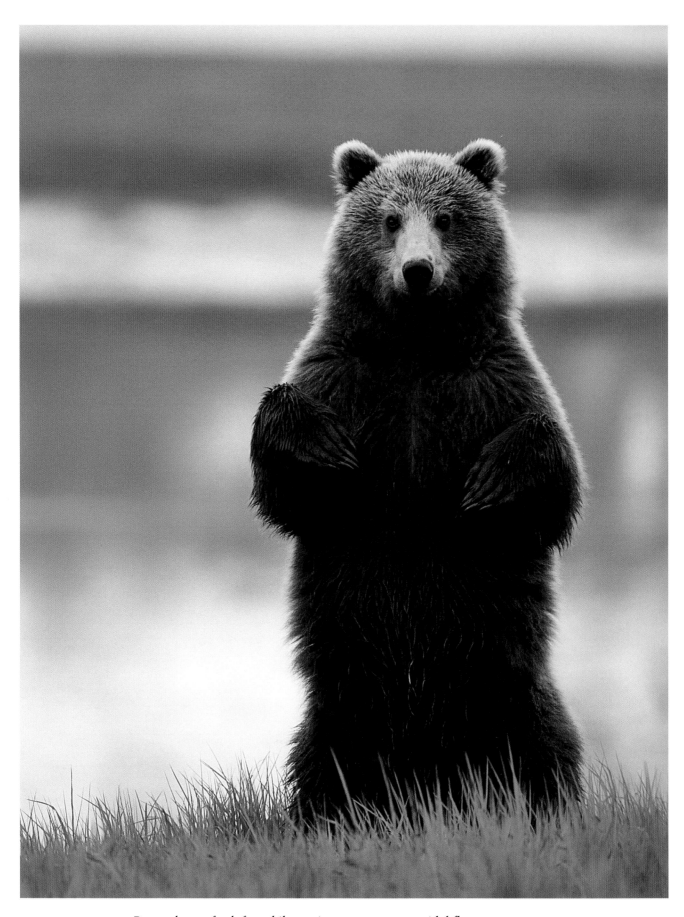

▲ *Brown bears, fresh from hibernation, congregate on tidal flats to gorge on new spring sedges. For protection, family groups stay close to cliffs or thick brush.*

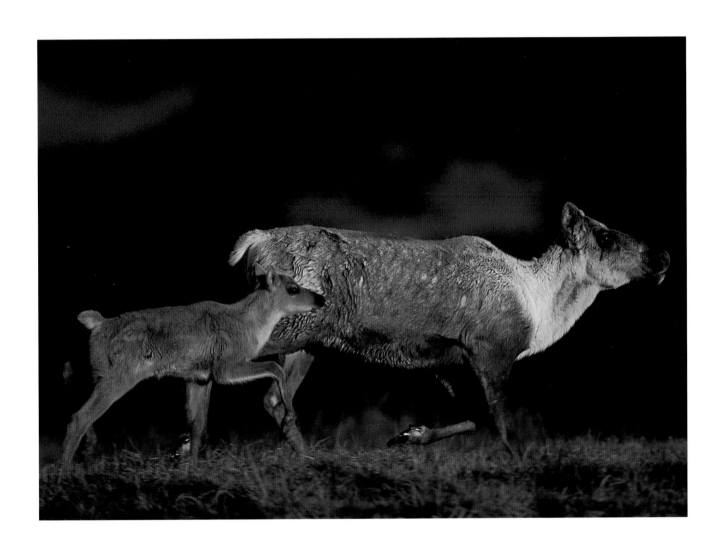

▲ *Caribou calves average thirteen pounds at birth and walk within an hour. Soon, they can keep pace with their mothers and in a few days can outrun predators and swim broad rivers. Fortified by a rich milk, calves double their weight in about twenty days. Migrations are perilous to young and old alike.*

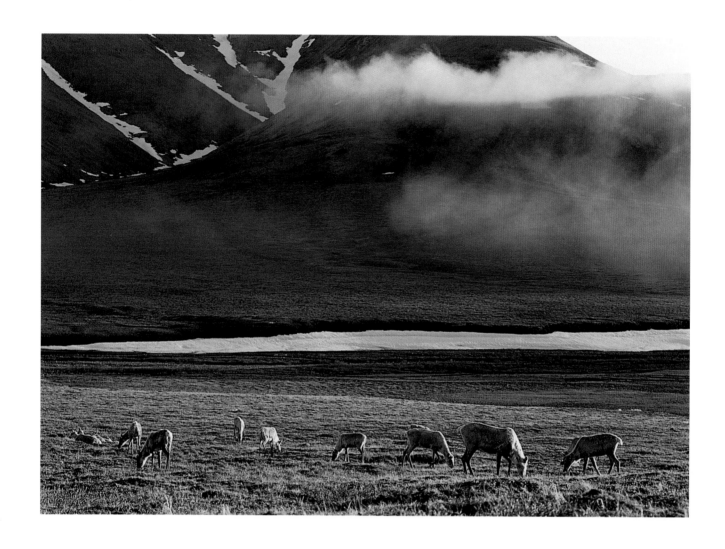

▲ *Caribou seem to be in perpetual motion. In the spring, arctic herds move north toward the coast from their southern wintering grounds long before the land is free of snow. Brooks Range valleys and slopes are warmer and snow-free weeks before the North Slope. Herds sometimes linger.* ▶ *The bald eagle is named for its conspicuous white head. This distinctive marking is not attained until birds are five or more years old. Juveniles have mottled head feathers.*

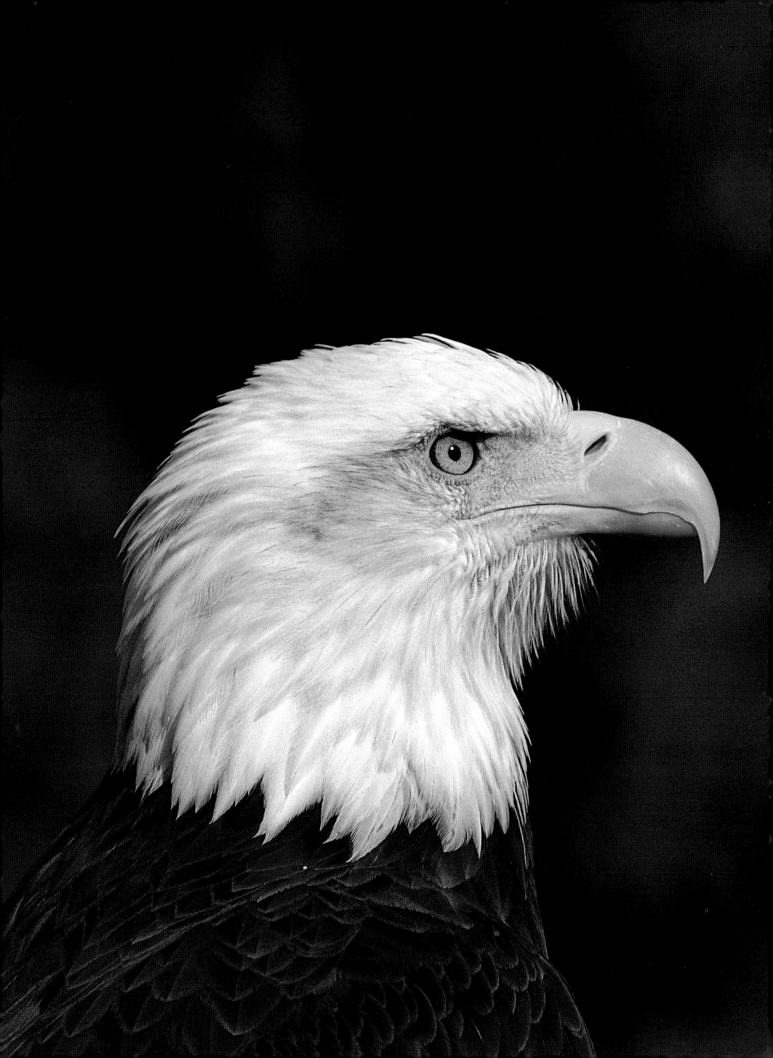

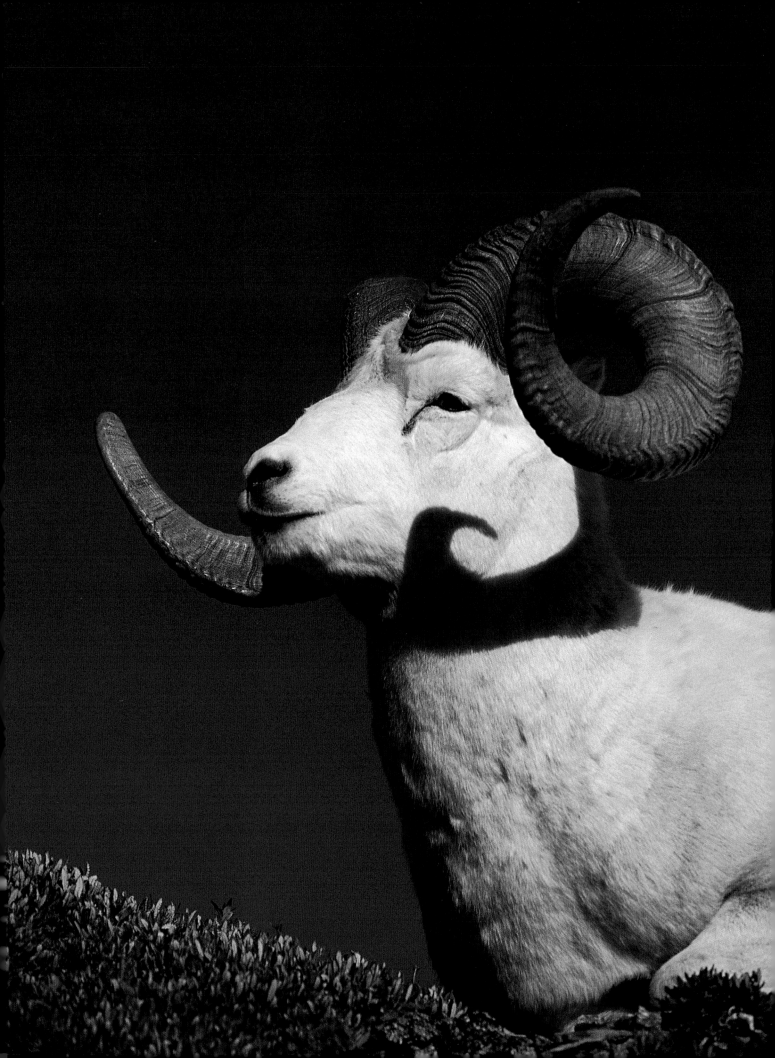

fire, sun, & thunder storms

In summer, the arctic sun does not set for weeks. In the subarctic, the sun sets briefly, and temperatures soar to 100° Fahrenheit. Lush summer thickets blanket the land. Plants seem to mature overnight, and biting insects torment almost every living creature. Bogs and muskeg are splendid hatcheries for *twenty-seven* mosquito species. There is even a specialized mosquito that lives off the Interior's only amphibian, the tiny wood frog. Tempest and tumult brew above the mountains, and lightning fires scorch the land. Fire is a gift. No large mammal can survive solely in mature forests. Fire is a creative force, rapidly recycling critical nutrients.

With rain and warmth, summer appears to be an easy time of year, but it is deceptive. Predators, disease, and accidents claim young and old. Some animals even die from insect harassment. Moose take to the water to feed on aquatic plants as well as to escape legions of bugs. Caribou bolt madly across the tundra to escape the mosquitoes and biting flies. On calm days, Dall sheep seek exposed summits looking for wind. There, they stand and endure. Life goes on. Yukon River salmon migrate fifty miles each day, some traveling as much as eighteen hundred miles from saltwater. Spawners fill streams, in death providing life to their own species as well as myriad other creatures. Everything lives, grows, and survives at the expense of others. Now, unlike winter, there is almost enough to go around.

◄ *Large ram horns—which grow year-round and are the product of nutrition, longevity, and genetics—are emblems of rank and dominance. The largest rams do most of the breeding.*

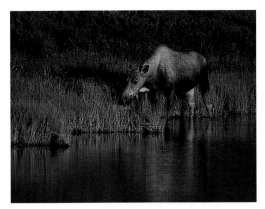

Cow moose eating aquatic plants

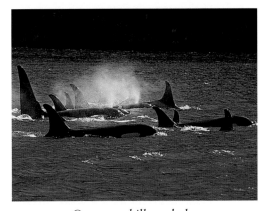

Orcas, or killer whales

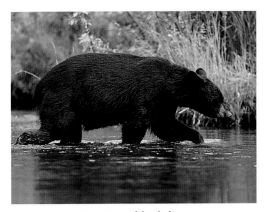

American black bear

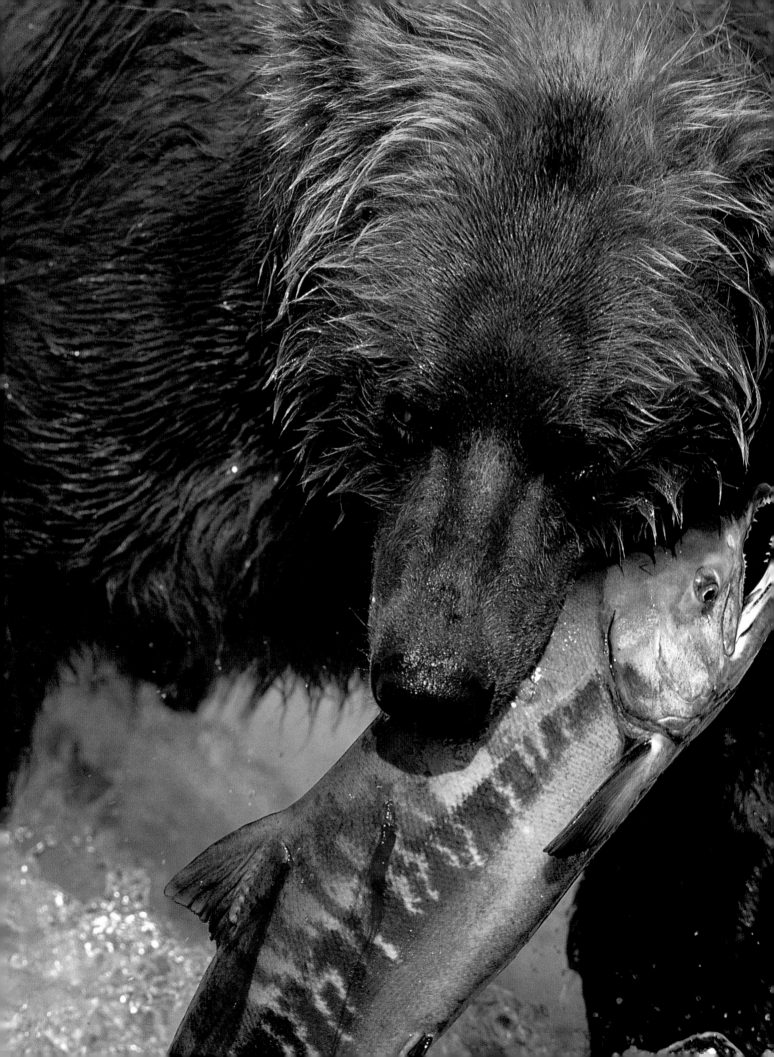

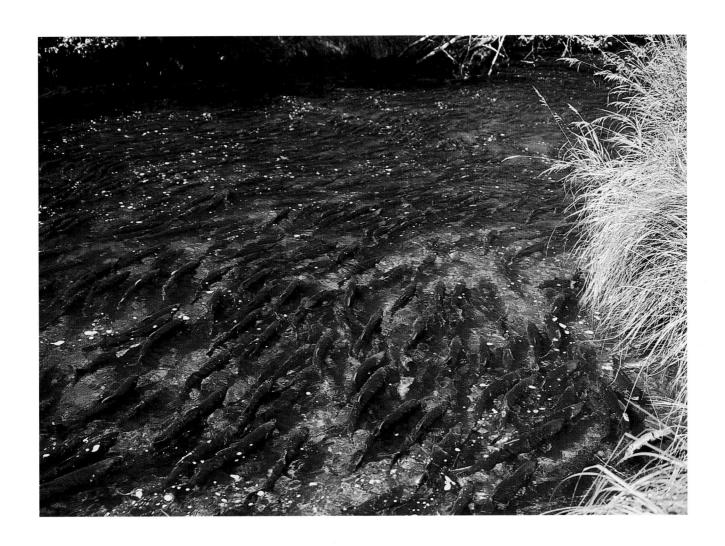

◄ *The largest brown bear males command the best fishing locations and catch fish with an economy of effort. During peak salmon runs at McNeil River, the diet preferred by bears is the nutritious skin and egg sacs of chum salmon.* ▲ *Red salmon spawn in streams flowing from lakes. They build nests, or "redds," in stream or lakeshore gravel. Also known as "sockeyes," these fish may spend one to five years at sea before returning to their natal waters.*

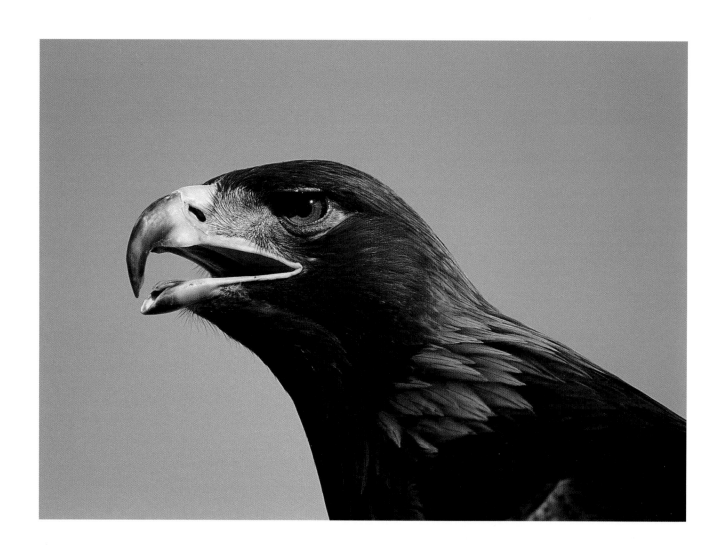

▲ *Golden eagles are mountain and tundra hunters. In rugged aeries, eaglets are fed pikas, ptarmigan, ground squirrels, and other small animals. The juvenile mortality rate is high, about 75 percent. Adult golden eagles also consume the leftovers of others' kills, such as those of wolves and other predators.*

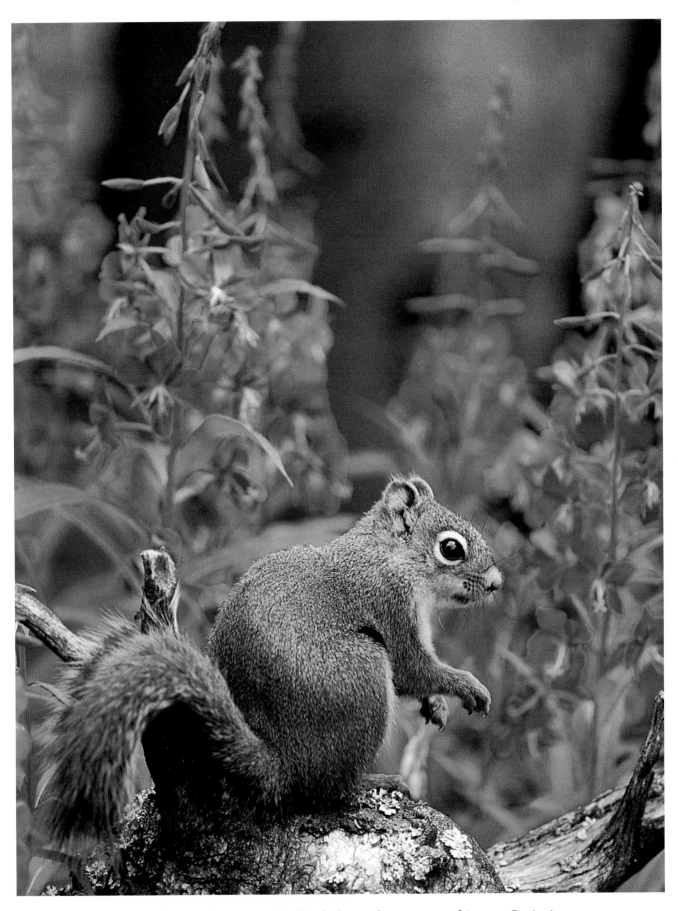

▲ *A red squirrel's summer food includes seeds, grasses, and insects. Beginning in August, spruce cones are gathered and stored for winter use. Squirrels aggressively defend their territories, which range in size up to about three acres.*

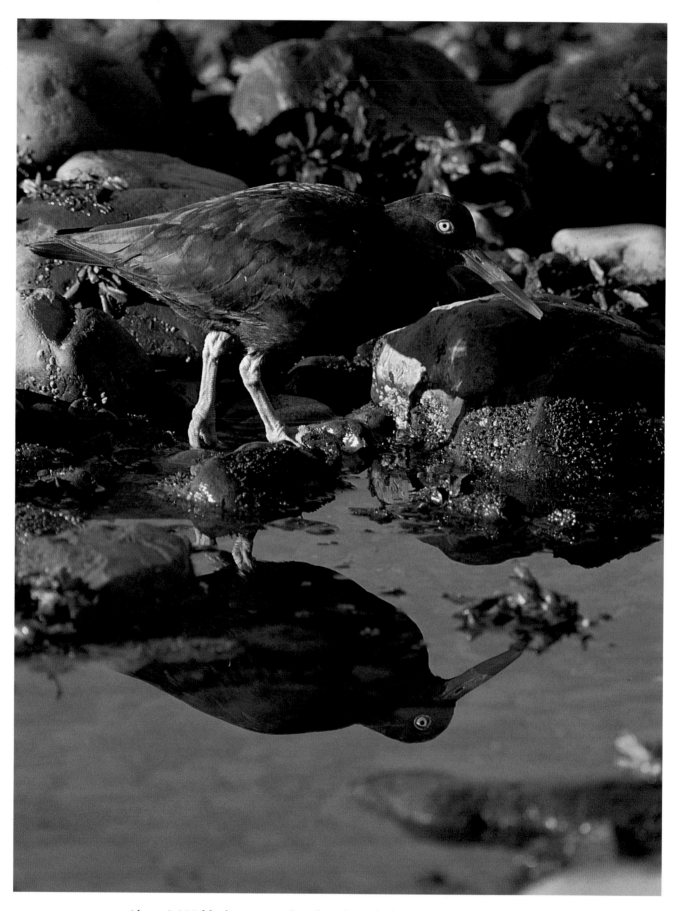

▲ *About 8,000 black oystercatchers breed in Alaska.* ▶ *Black-legged kittiwakes, common murres, and horned and tufted puffins share nesting cliffs.* ▶ ▶ *Adult male walruses can weigh over two tons and sport tusks almost three feet long.*

34

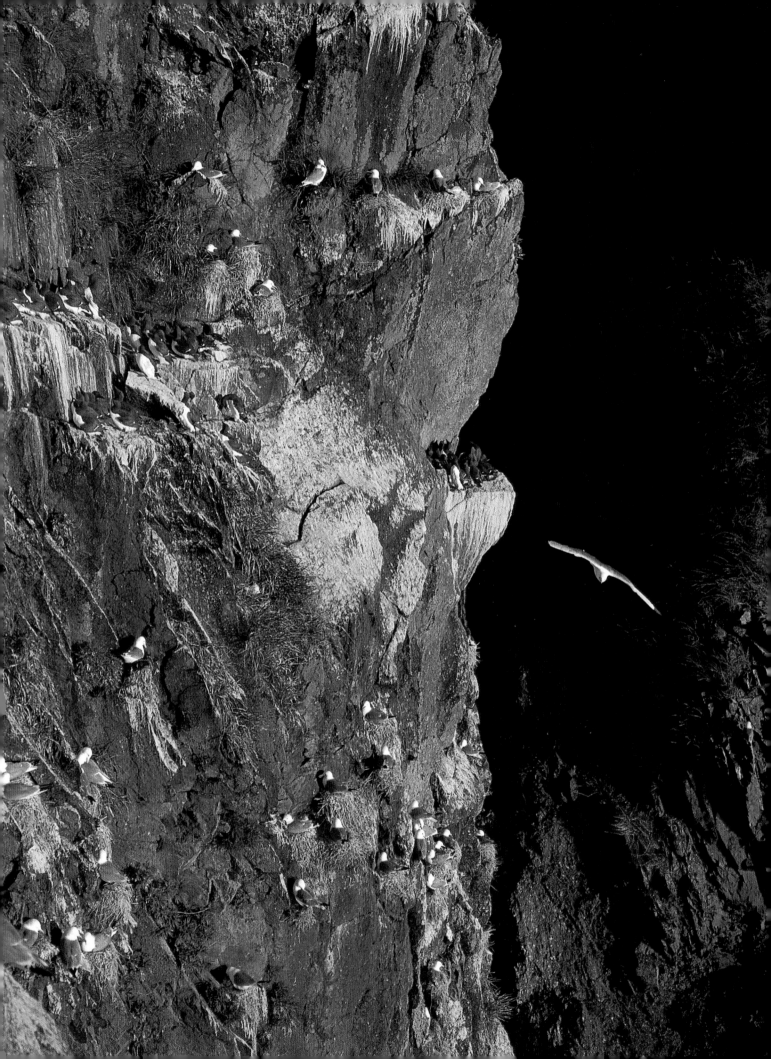

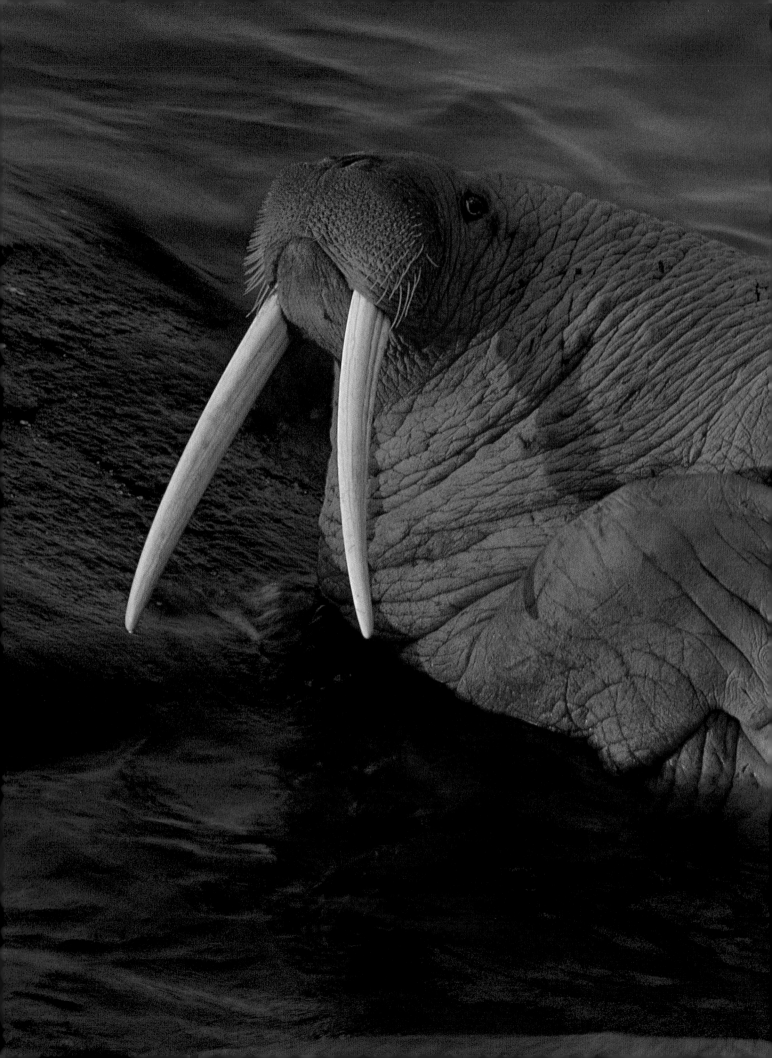

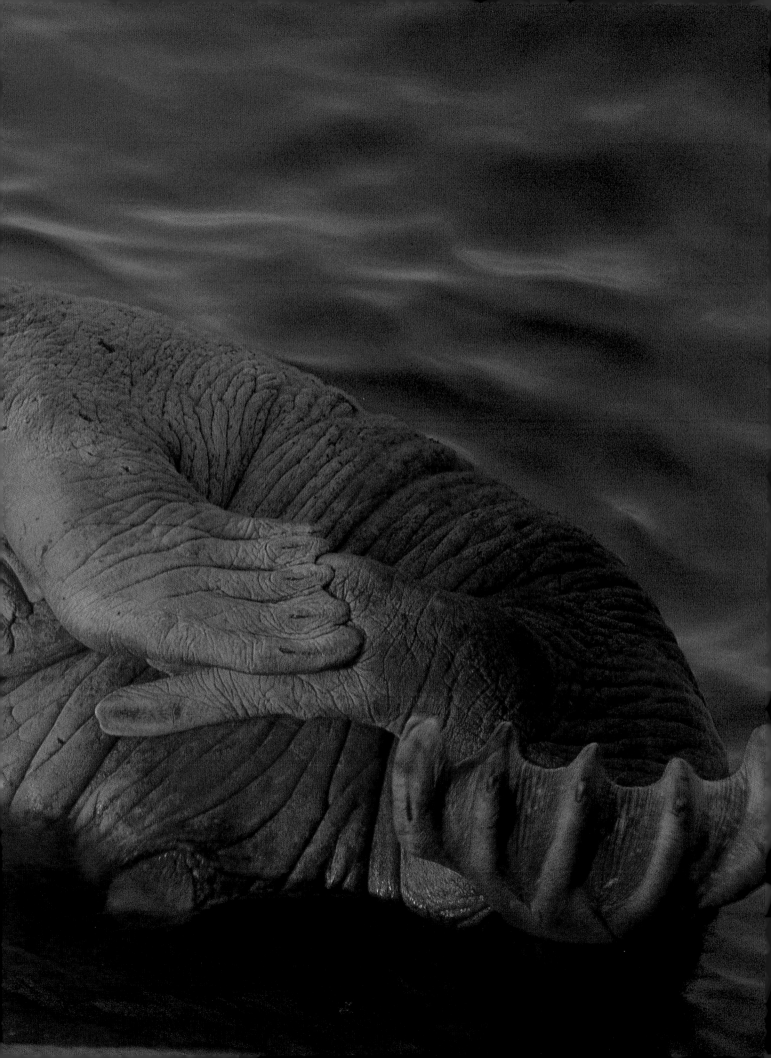

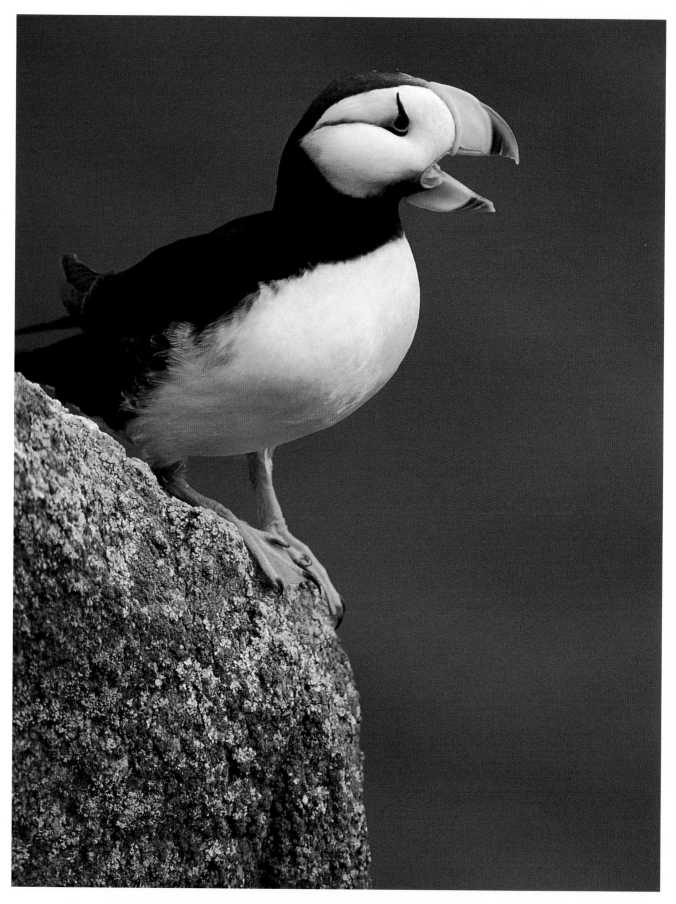

▲ Male and female horned puffins share in incubating eggs and feeding hatchlings.
▶ Sometimes called "killer whales," orcas in Alaska number about four hundred.
▶ ▶ The humpback whale's name is derived from its arching dive pattern.

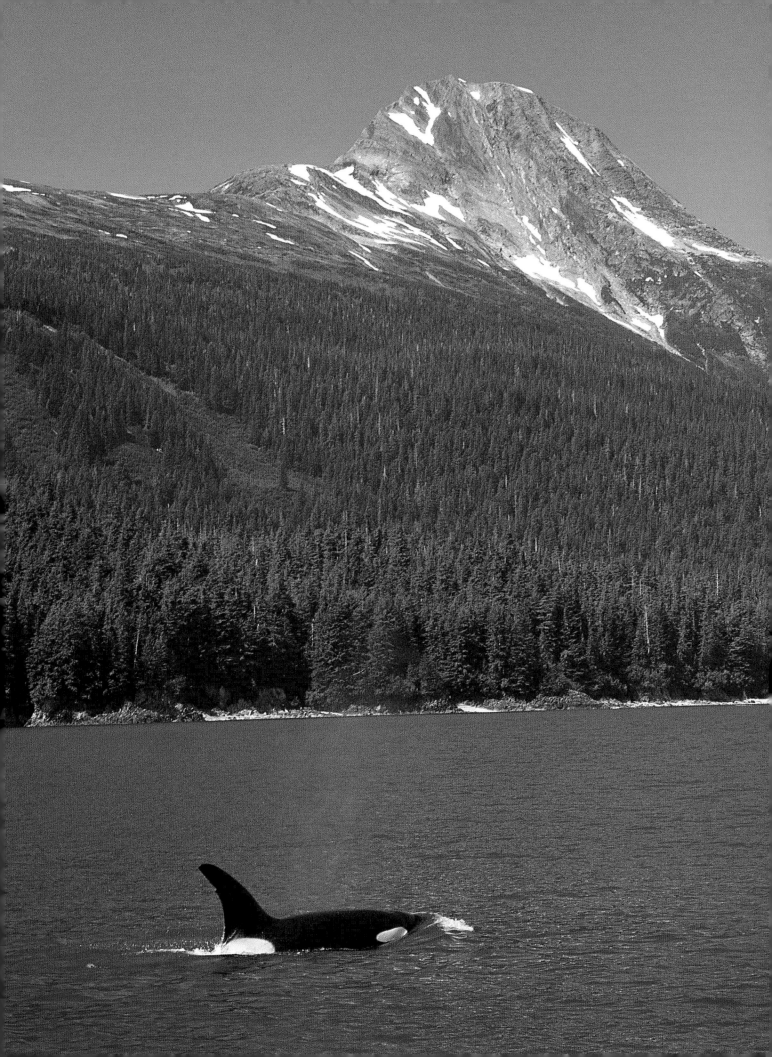

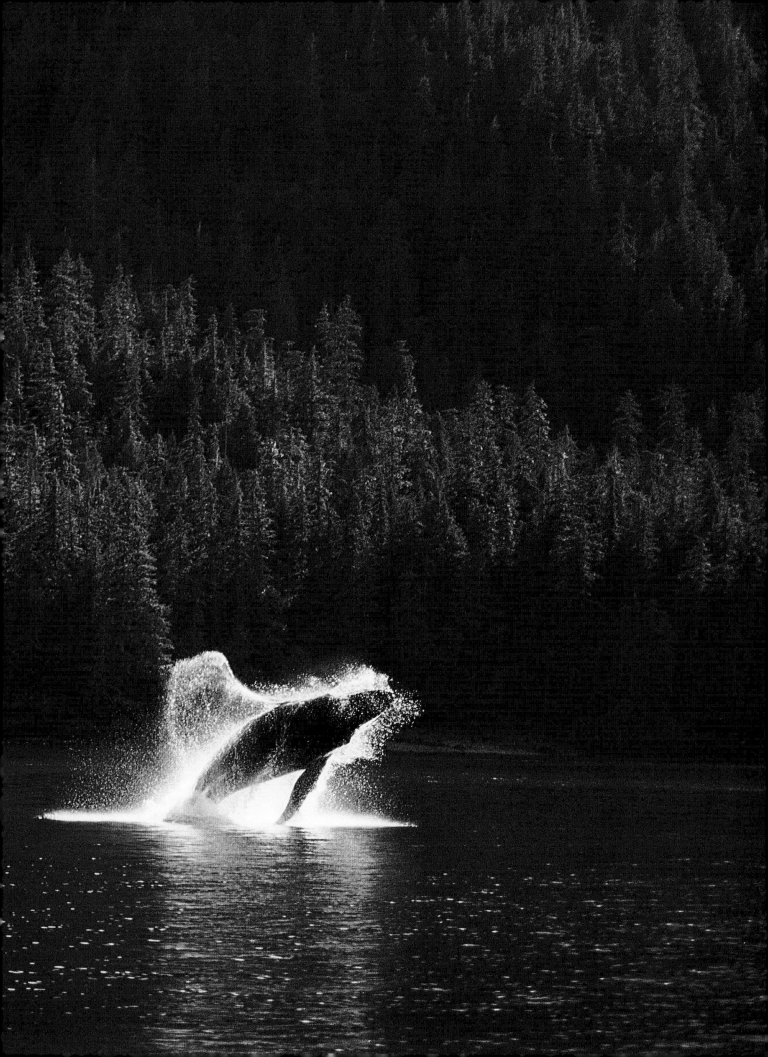

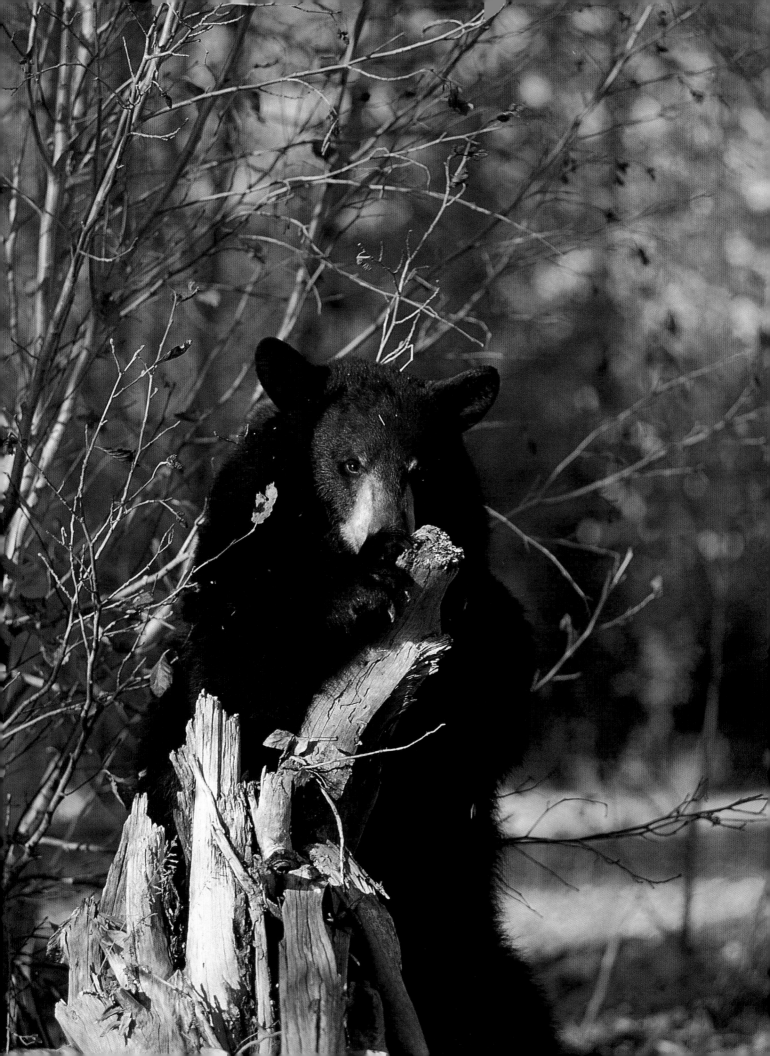

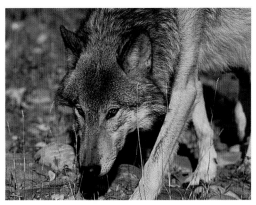

Gray wolf

glitter of frost & stars Autumn is the season of painted leaves. Sere grasses gleam in the late afternoon sun, and crimson leaves flutter in the wind. Ice forms on tundra ponds, and storms dollop the peaks with snow. It is only the end of August, but already winter has arrived on the arctic shore. Pelage begins to lengthen, and underfur to thicken; plumage develops, and young wings gain strength. All through the lengthening night, foraging accelerates as animals fatten for migration, the rut, or winter survival. Winter's lantern—the aurora borealis—already hangs in the sky.

Diminishing daylight triggers reverse migrations, feeding binges, food gathering, hibernation preparations, rutting seasons, and pelage and plumage color changes. Flocks of ducks, geese, swans, and cranes, all bolstered by summer broods, fill the sky with cacophonous anthems. Sheep dare lowland passes on the way from the high peaks to ranges of lesser snowfall. Caribou herds ford flooding rivers. Black and brown bears gorge for hibernation. Pikas, red squirrels, muskrats, and beavers work to expand winter larders. Anticipating months of ice-locked confinement, beavers and muskrats strengthen and refine their lodges. Bull moose, elk, deer, and caribou polish their antlers in anticipation of battle. Marmots and ground squirrels ready their dens. All creatures hedge against the famine overtaking the land. It is the day before winter.

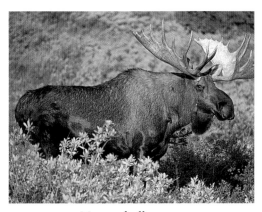

Mature bull moose

◄ *Black bears eat berries, fish, and anything else they can find—including insects in rotten logs.* ▶ ▶ *Natural obstacles slow down but don't stop migrations of arctic herds. Sexes frequently mingle during migration, but groups of bulls often travel alone. Antlers freshly stripped of velvet are stained red from the blood that nourished their growth.*

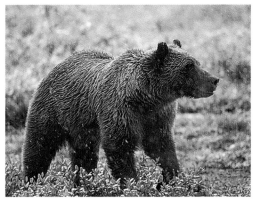

Interior Alaska grizzly bear

43

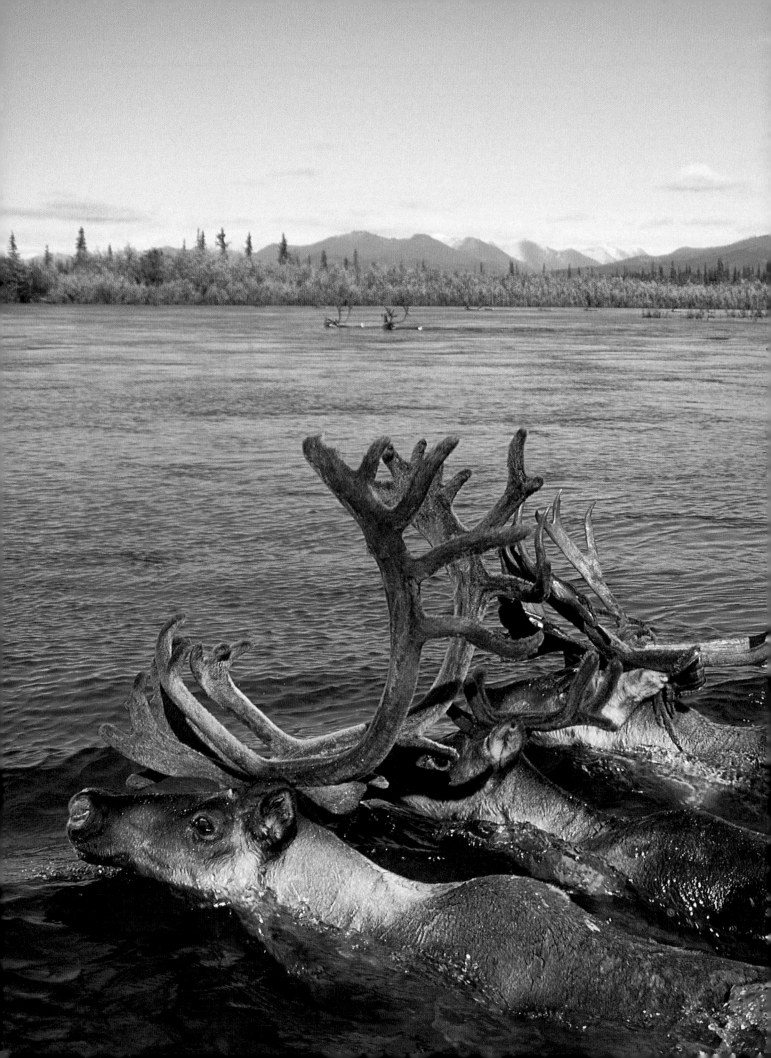

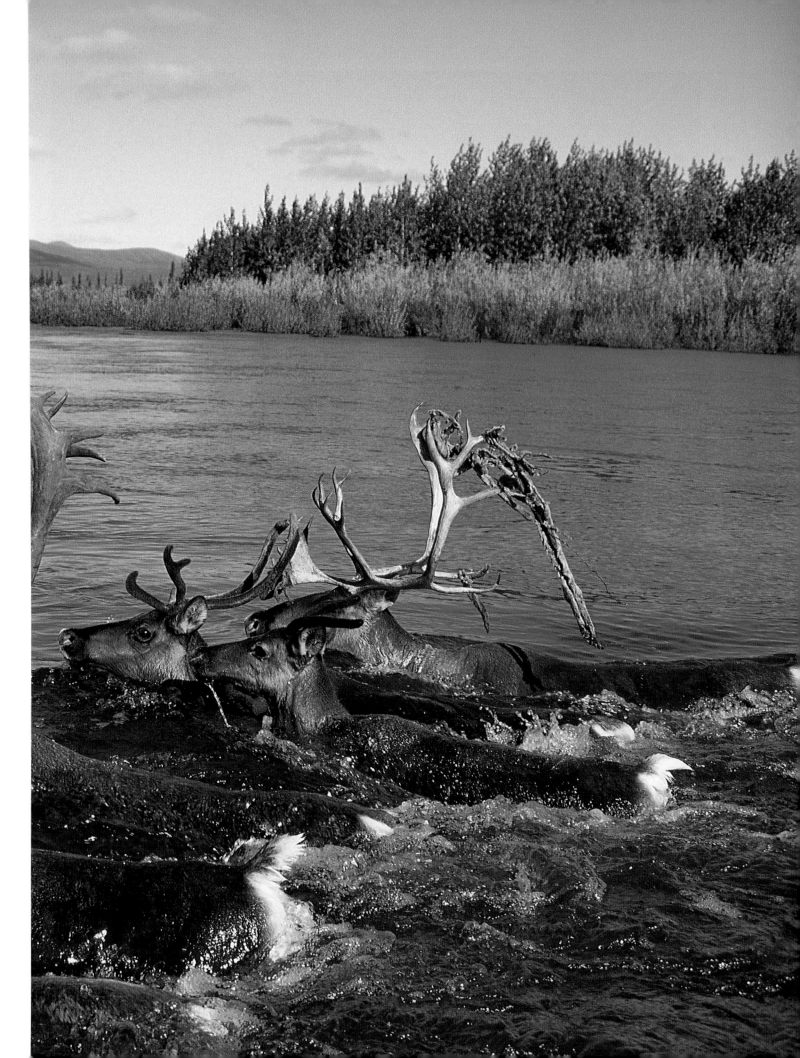

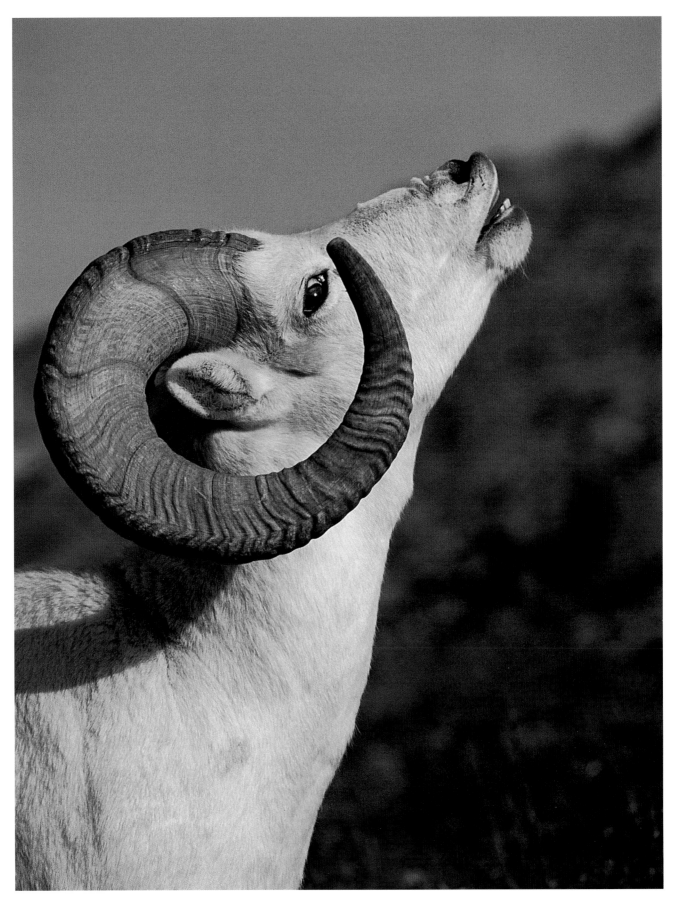

▲ *A ram "lip-curls" to judge a ewe's receptivity to breeding. Common to many animals, the lip curl, or* flehmen, *is a response to olfactory stimuli. By holding the head back and curling the lip, odor is held for processing by the Jacobson's organ.*

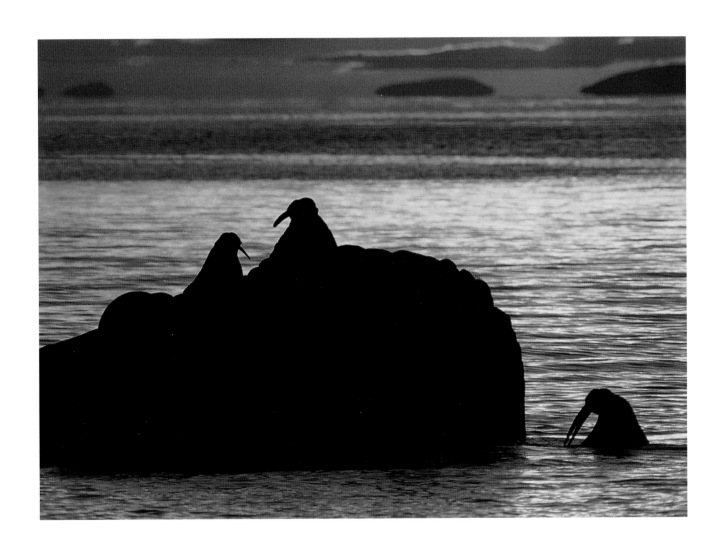

▲ *Gregarious walruses gather on ice floes or rocky shores. Land "haul-outs," though uncommon, are important sites. Walruses are awkward on land, but are agile swimmers. Searching for food, they can dive for six to ten minutes, reaching depths of 30 to 150 feet. Using their whiskers, called* vibrissae, *walruses root in the mud for bivalves. They suck the meat from the shells.*

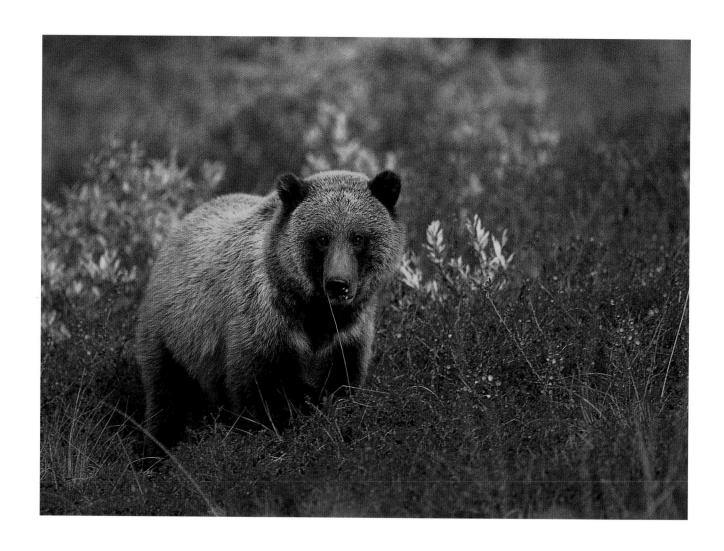

▲ *The only difference between "brown" and "grizzly" bears is, perhaps, habitat. Many grizzlies depend on berries instead of fish for the fat reserves necessary for hibernation.* ▶ *Mineral licks are often muddy, standing water. Moose and other herbivores drink the water and eat the mud for the mineral content. These magnesium- and calcium-rich soils balance out the potassium from plants and may rid the system of internal parasites. Calcium and phosphorus help build strong antlers and horns.* ▶▶ *The first autumn dusting of snow often triggers migrations. This Dall sheep ram is on winter range, where it forages through the snow.*

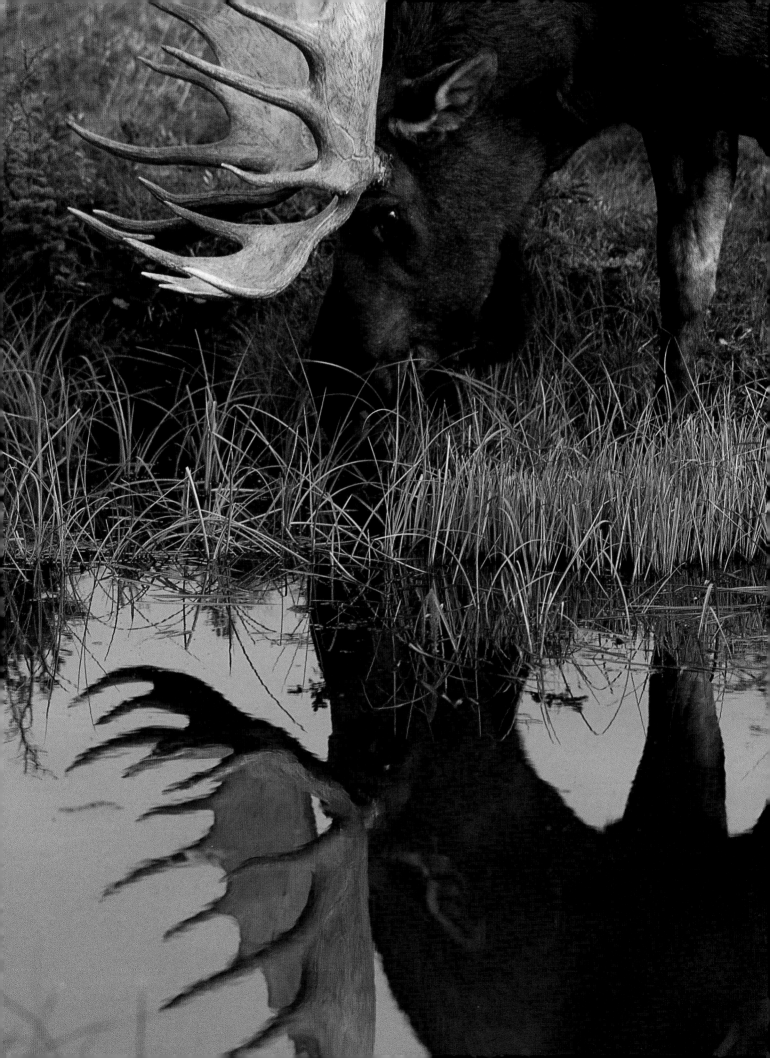

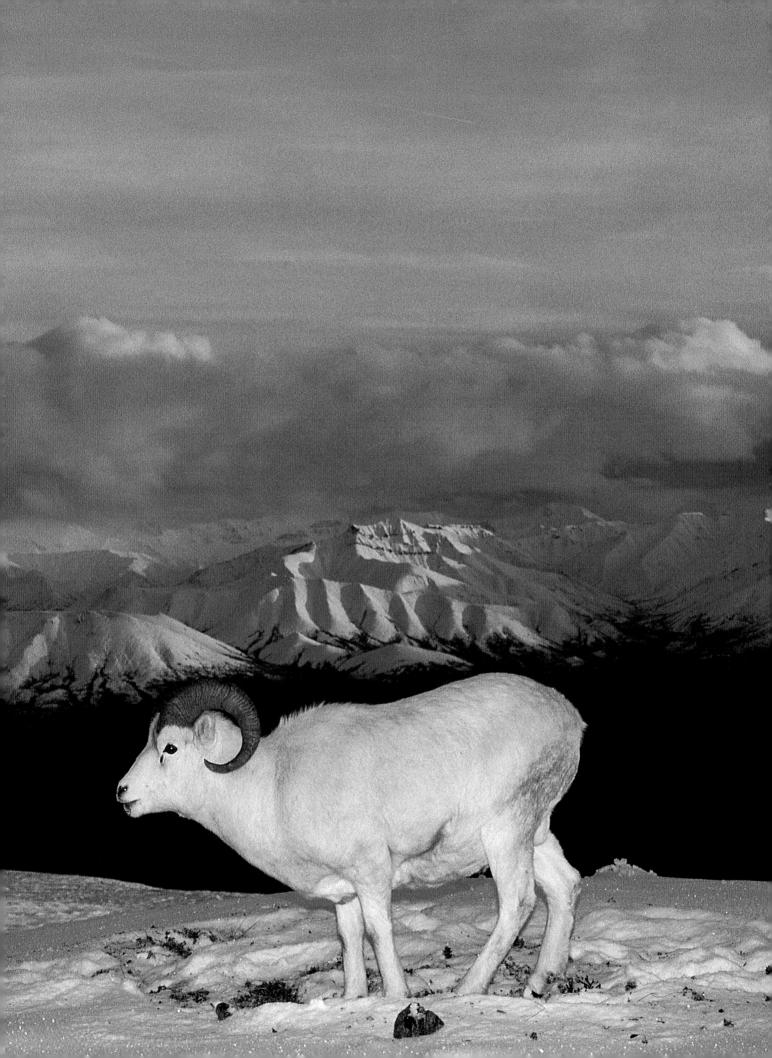

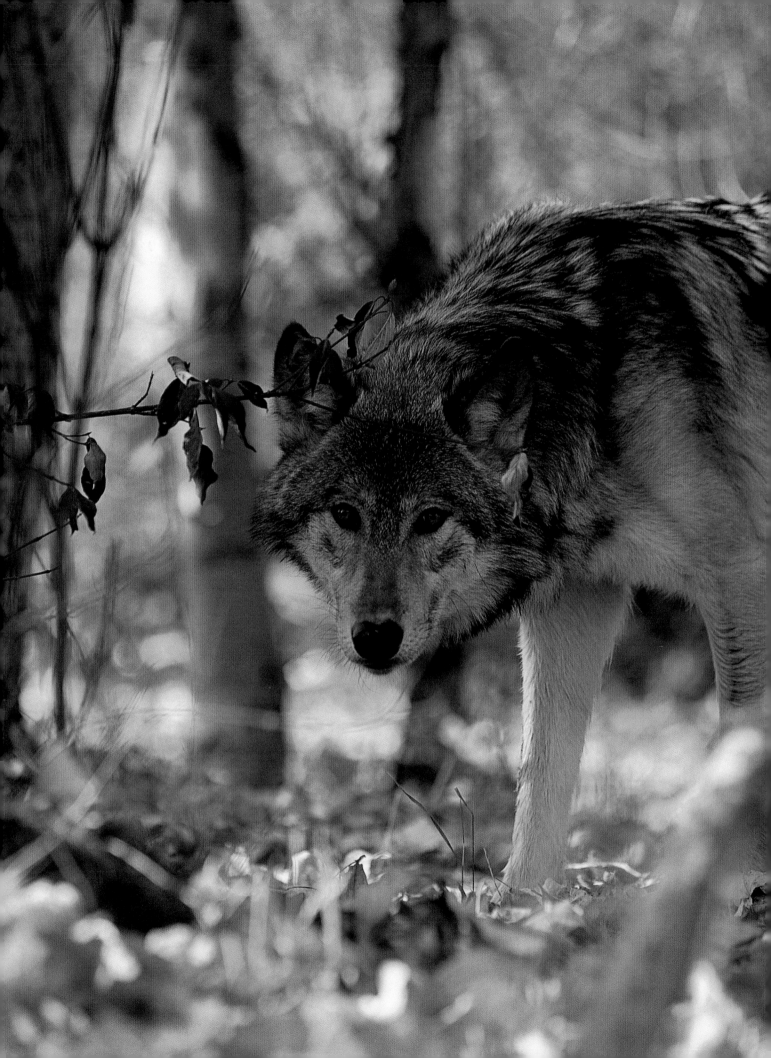

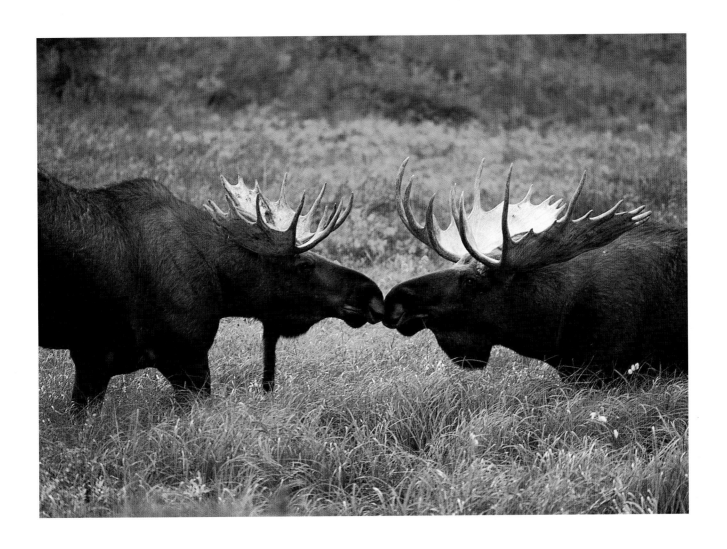

◄ *Wolves travel watercourses over mountain passes, ever alert for prey. In areas of heavy brush and timber, wolves are seldom seen. Tracks and howling may be the only signs of their existence. Wolves hunt both large and small animals. Squirrels, beavers, and snowshoe hares are important to wolves' diet.* ▲ *When moose touch noses, they experience an intense exchange of information. Only moose understand the message.* ►► *In 1932, only 69 trumpeter swans were counted world-wide. By 1990, 13,340 trumpeter swans, perhaps 80 percent of the world's entire population, were counted in Alaska.*

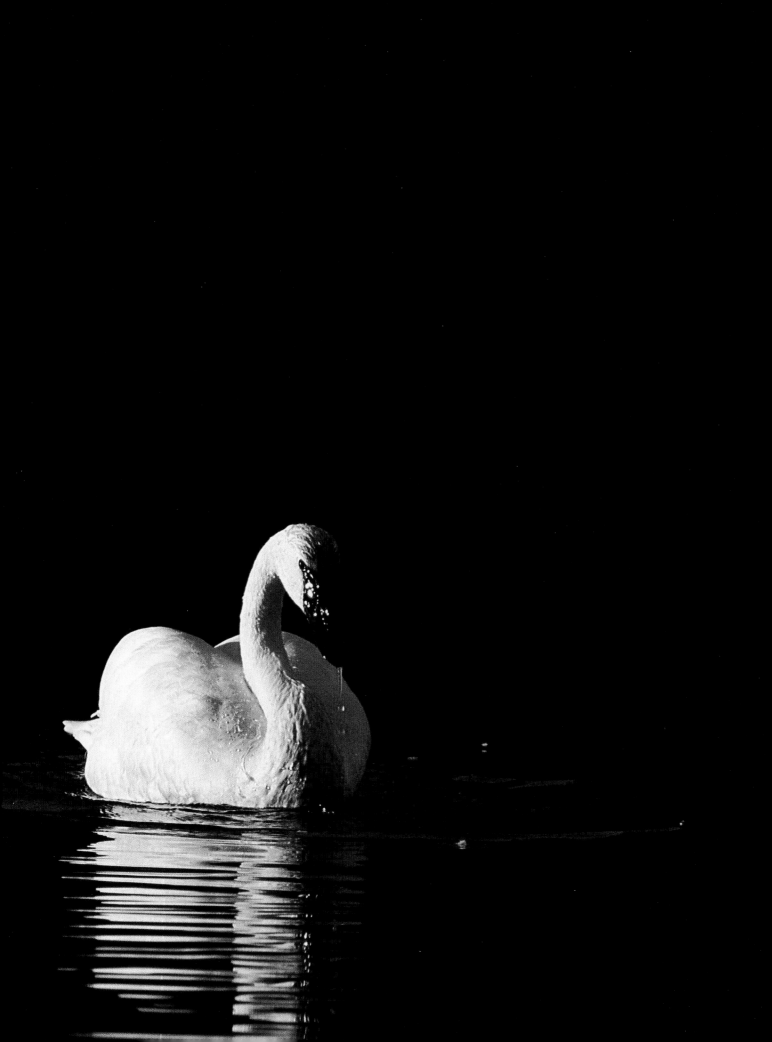

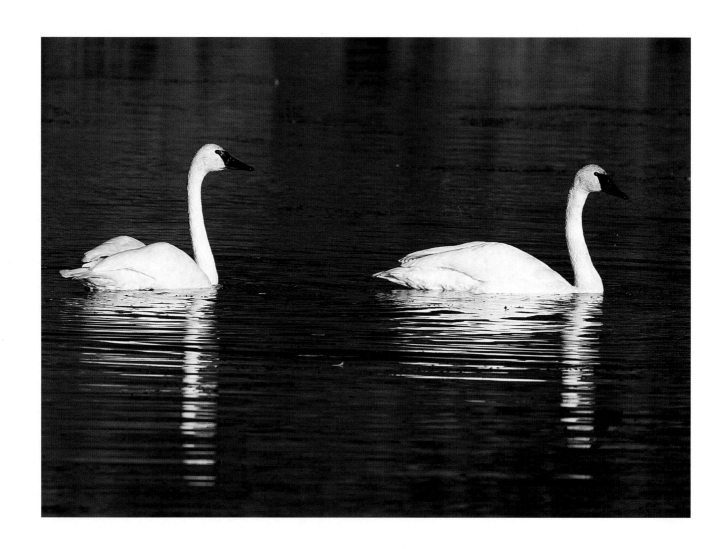

▲ *Trumpeter swans are the largest of all waterfowl. Males (cobs) average twenty-eight pounds; females (pens), twenty-two pounds. Some weigh up to forty pounds, with wingspans of six to eight feet. Mated for life, a cob and pen share in the rearing of their young (cygnets) and migrate south together in autumn.* ▶ *In order to retain the warmth and waterproofing of plumage, waterfowl, like this hen mallard, spend much time preening. During mid-summer molt, when feathers are lost and regrown, preening helps keep the flightless birds buoyant and warm.*

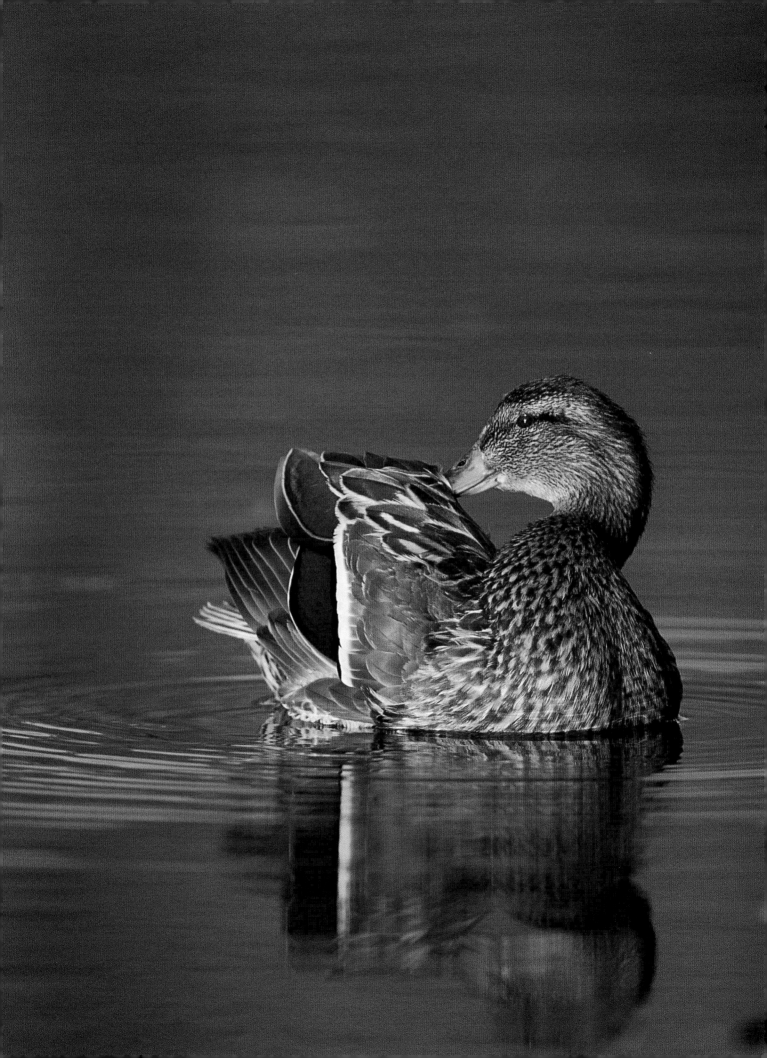

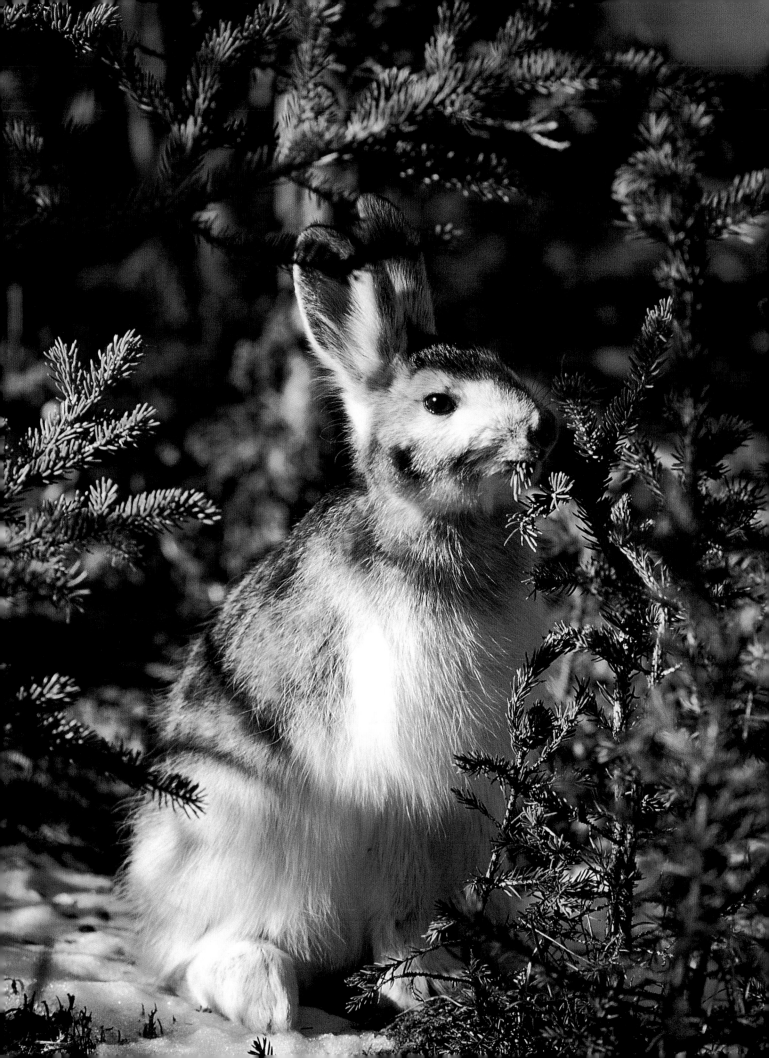

snow, darkness, & cosmic cold

Winter brings the cold, a dark time of testing when there is never enough to eat. Temperatures plunge to a record minus 80° Fahrenheit, and winds push the chill to beyond minus 100°. Some regions have scant snowfall; others have daily accumulations that can be measured in *feet*. Drifts are deep and often rock-hard, locking away forage plants beneath. Above the Arctic Circle, the sun never rises, and in the Interior, *days* are scarcely five hours long. In the far north, the terms *diurnal* and *nocturnal* lose meaning. *All* residents become creatures of the night.

Gone are the migrants; gone to bed are those least able to cope with winter. Most simply persist. Musk oxen, with their superb shaggy coats, are poorly adapted for grazing in deep snow. Their range is limited to areas of low snowfall and windblown ridges. Sheep also graze wind-shorn slopes, depending on dense, hollow-hair coats and fat for protection from the wind and cold. Moose browse woody plants. Caribou paw through the snow for lichens, located through the snow by smell. Antlers, unneeded for survival, are shed. No matter how much dried forage the browsers and grazers consume, it is stored fat that determines survival. Arctic foxes shadow polar bears to pilfer scraps. Predators make kills and scavenge others. They have no real advantage; starvation is indiscriminate in the long darkness.

◄ Lessening daylight in autumn triggers color changes in the snowshoe, or "varying" hare. "Snowshoe" refers to the hare's large hind feet. Weather fluctuations sometimes catch hares out of color synchronization with the ground cover. A brown hare on snow is easily seen; a white one on bare ground is also vulnerable.

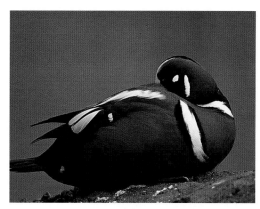

Drake harlequin duck

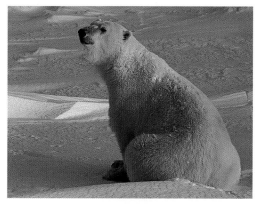

Polar bear

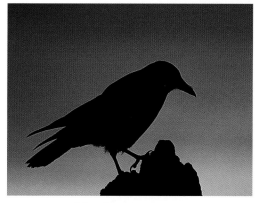

Northwestern crow

61

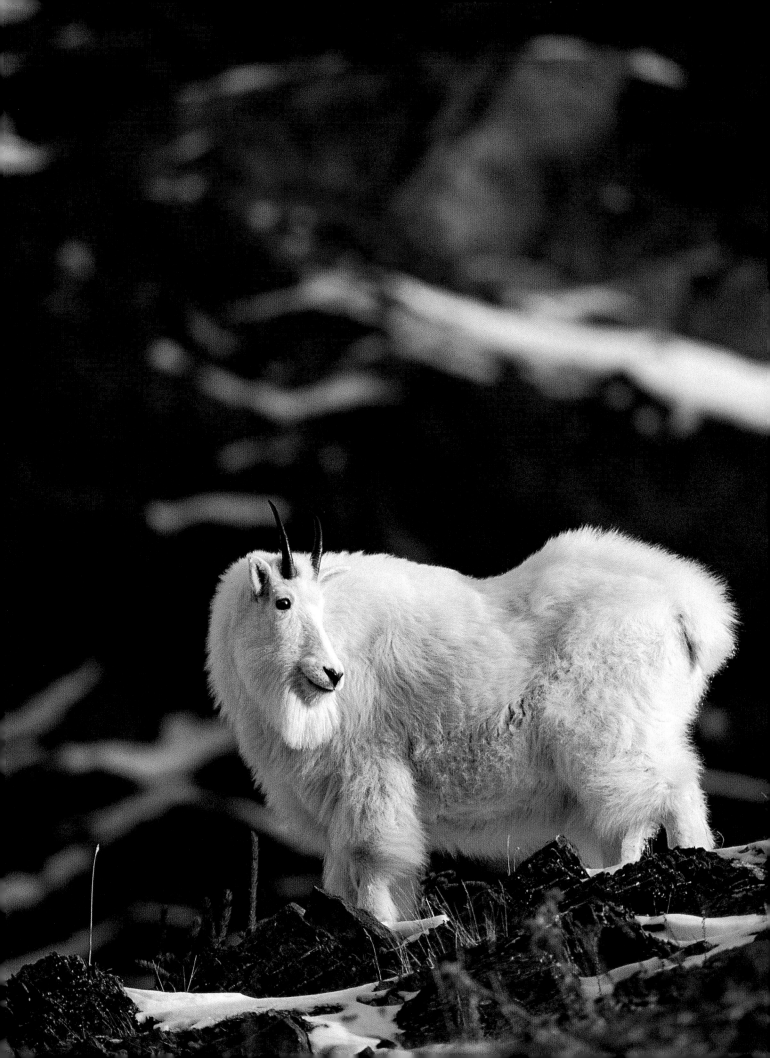

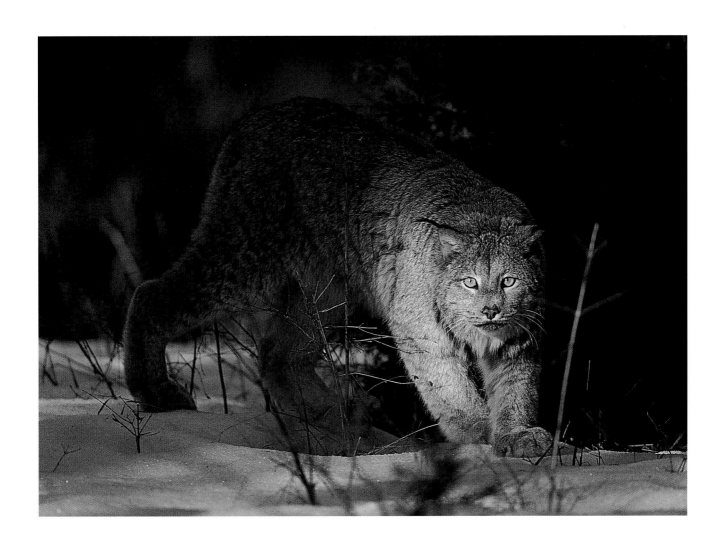

◄ *To survive in areas of deep snow, mountain goats sometimes winter in forests, on coastal cliffs, or even descend into intertidal areas. Hemlock is a winter forage.* ▲ *Armed with well-furred, saucer-sized paws and aided by excellent night vision and sharp hearing, lynx are principal predators of the snowshoe hare. Lynx populations rise and fall along with the ten-year hare cycle. Both populations fluctuate according to abundance—from up to eighteen hares per acre to scarcely any. Lynx have moved as far as four hundred miles in search of hare abundance.*

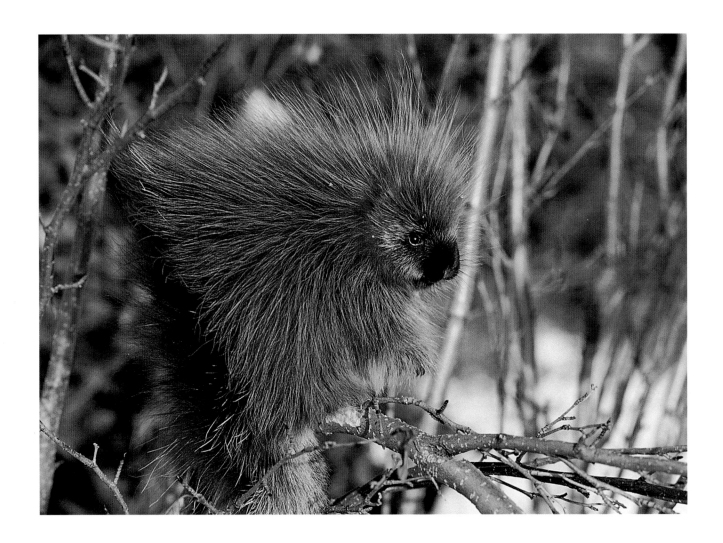

▲ *In early winter and again in spring, the bark, buds, and twigs of willow and birch become part of a porcupine's diet. An arsenal of barbed quills protects this myopic, slow-moving animal from all but the most skilled predators. Even brown bears have suffered debilitating injuries from incautious contact with porcupines. At birth, baby porcupines (porcupettes) are covered with long, grayish-black hair that, within hours, dries into protective quills.* ▶ *Snowshoe hares are well adapted for winter. Their coloring offers camouflage from predators, and their large hind feet enable them to outrun foxes and coyotes, which flounder in deep snow.*

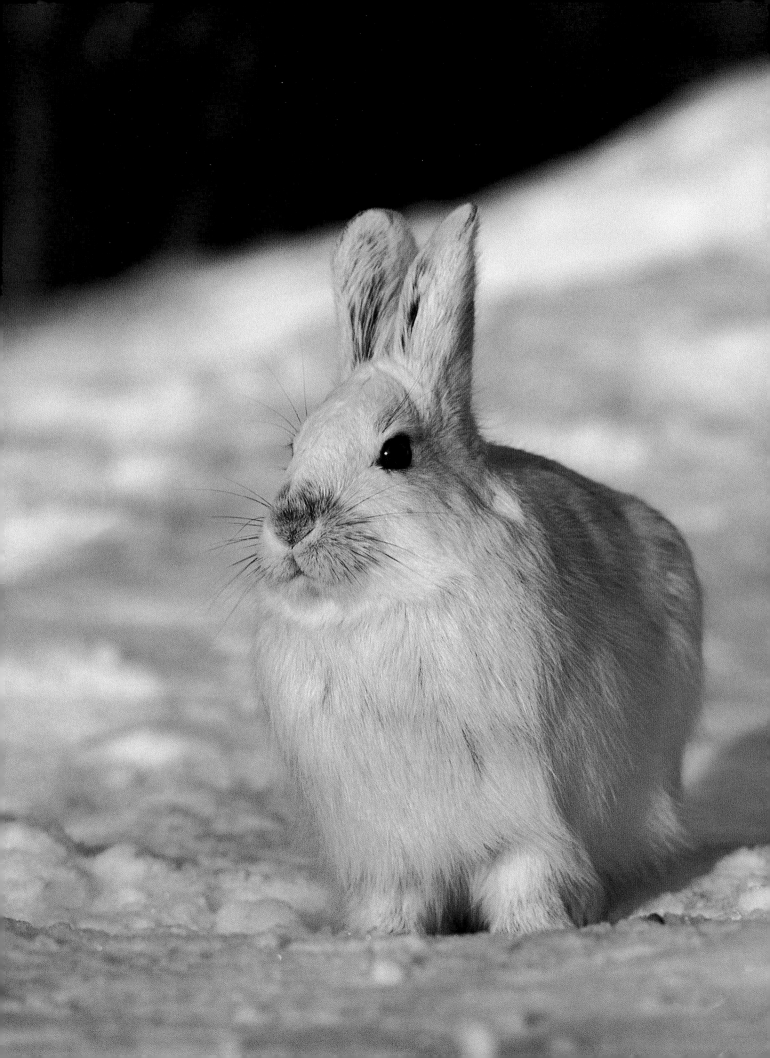

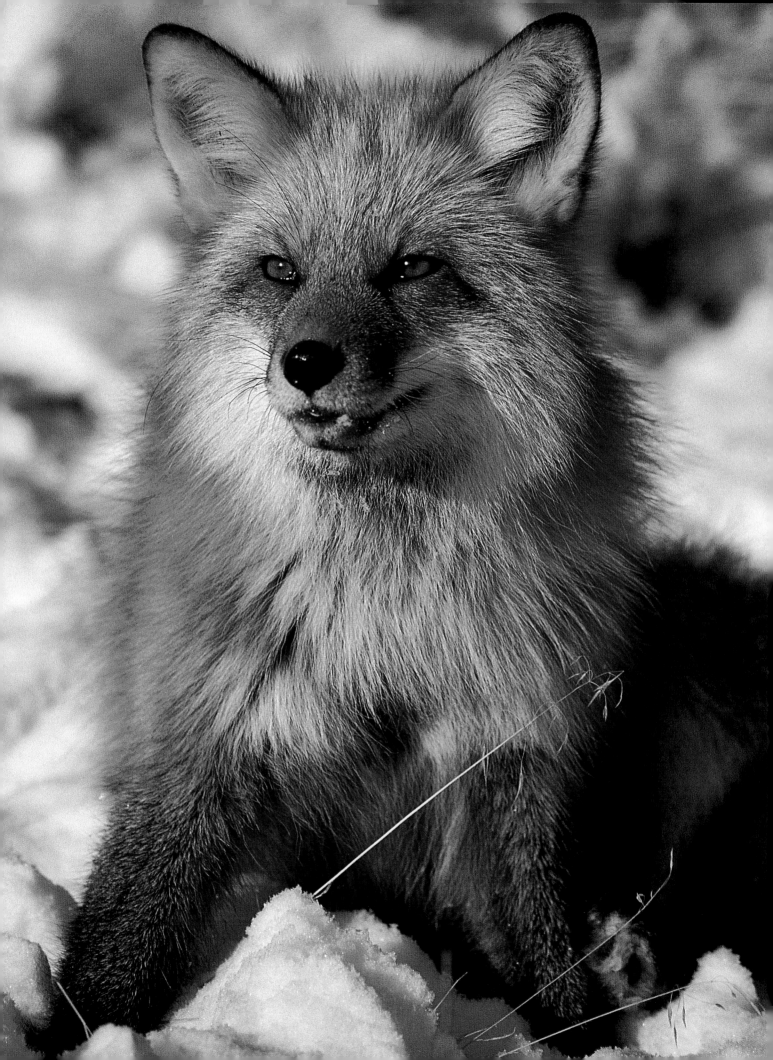

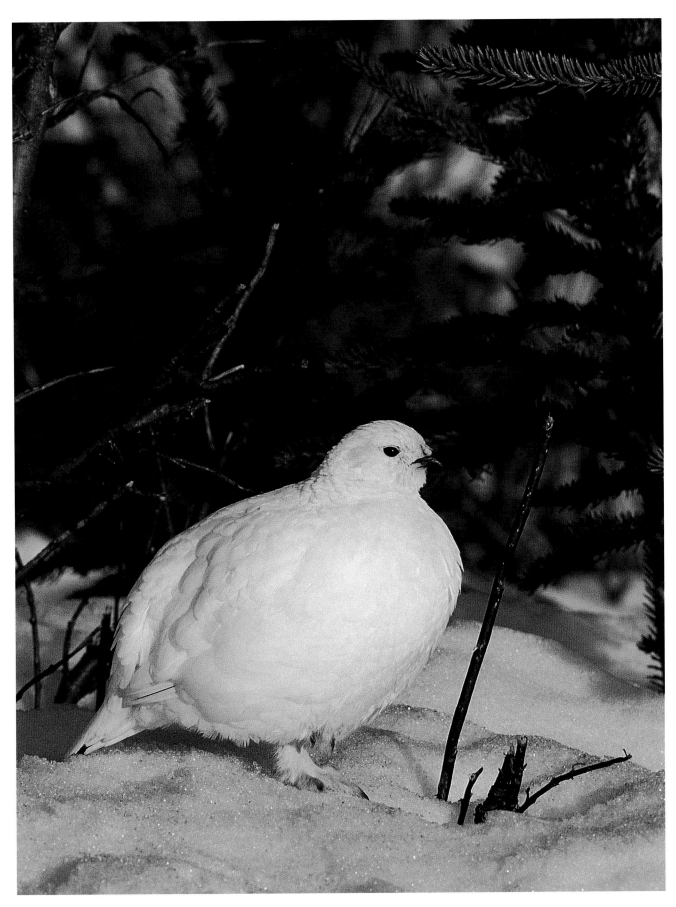

◄ *Red foxes are found in all habitats from forest to plain.* ▲ *Willow ptarmigans migrate up to 150 miles between summer and winter ranges.* ►► *Prior to 1900, musk oxen in Alaska had been wiped out by hunters.*

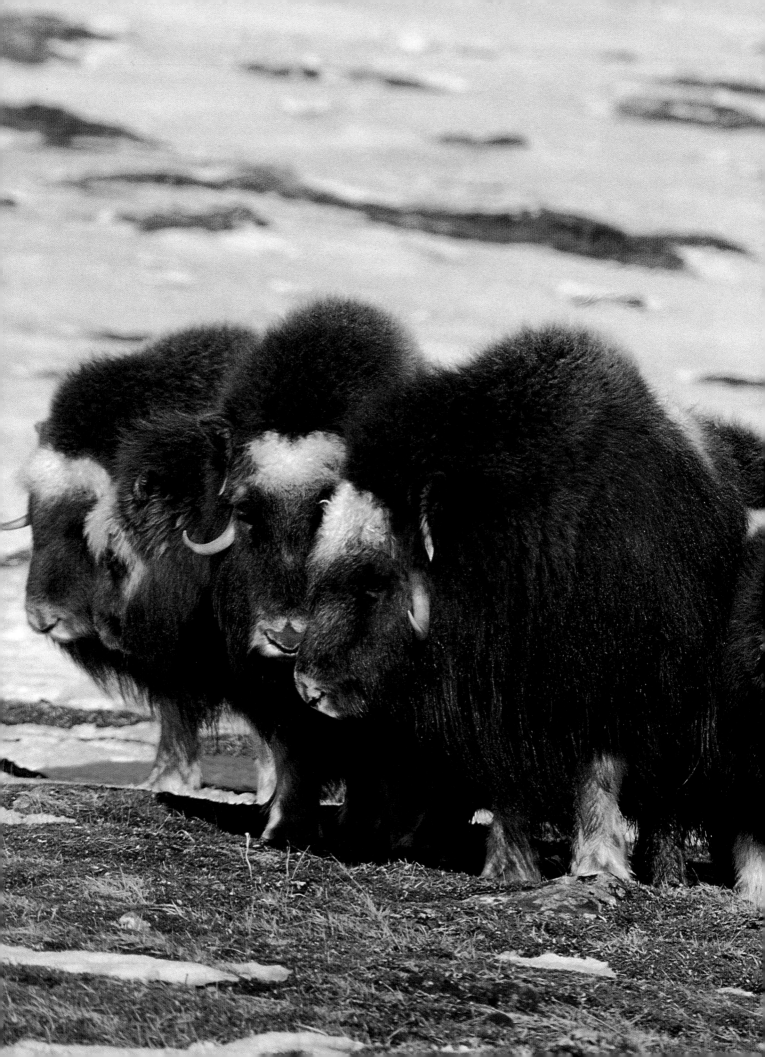

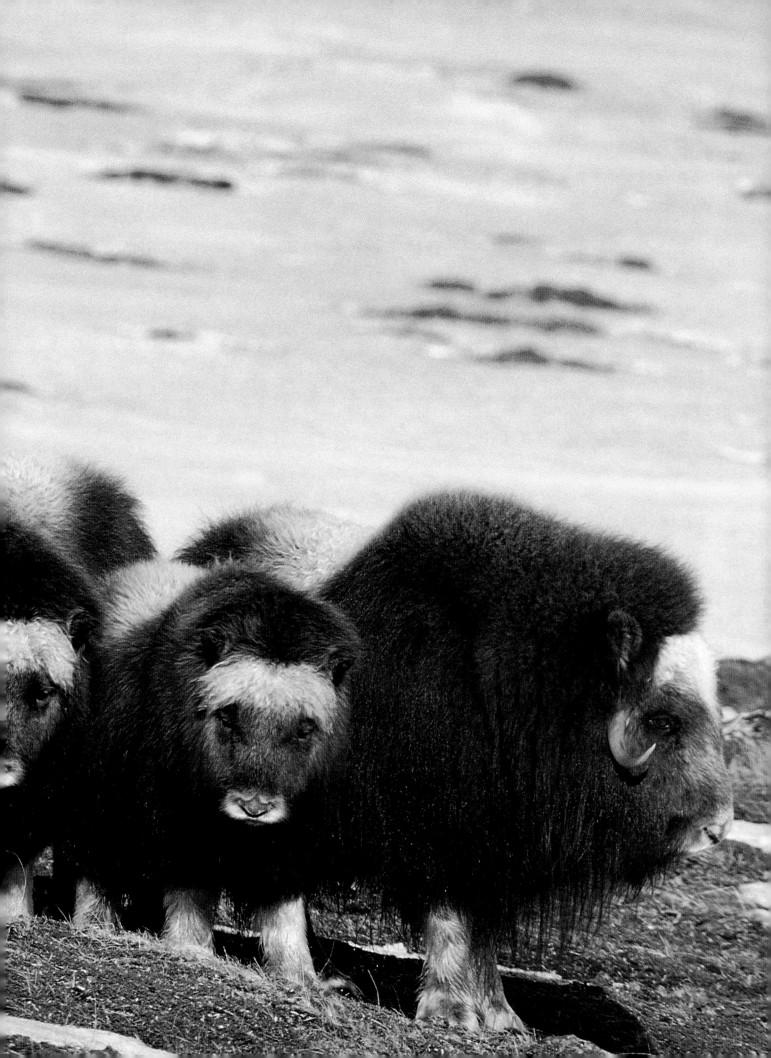

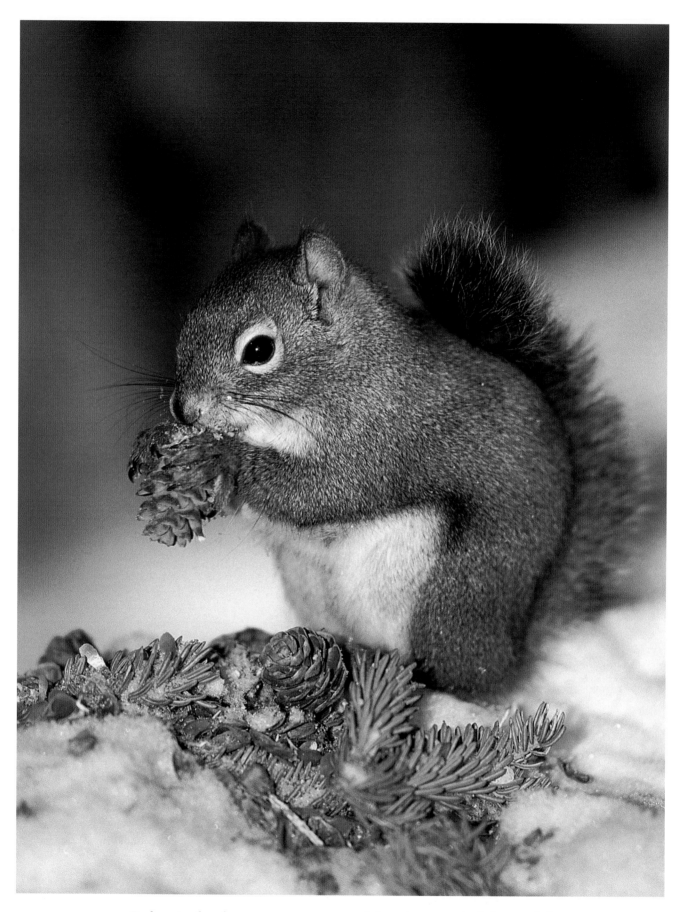

▲ *Red squirrels rely on spruce cones stored for winter survival. Research has revealed that squirrels are adept at avoiding predators. Martens live off rodents, not squirrels. Surprisingly, red squirrels are predators of baby snowshoe hares.*

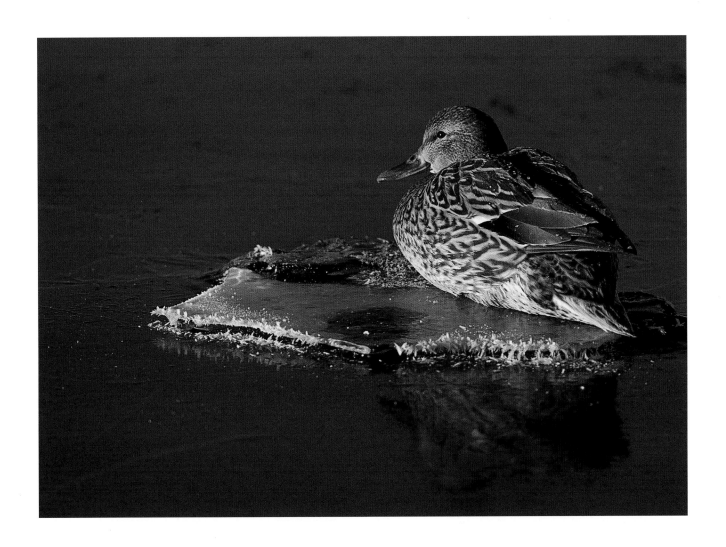

▲ *The hardy mallard is among the last waterfowl to migrate south each autumn and the first to return. Large numbers of mallards, like this hen, overwinter in Alaska.* ▶ ▶ *The arctic sun does not rise above the horizon for weeks. When it does, it offers no warmth to the arctic fox. Dense underfur and long guard hairs protect foxes from bitter winter extremes. Food intake is critical to survival.*

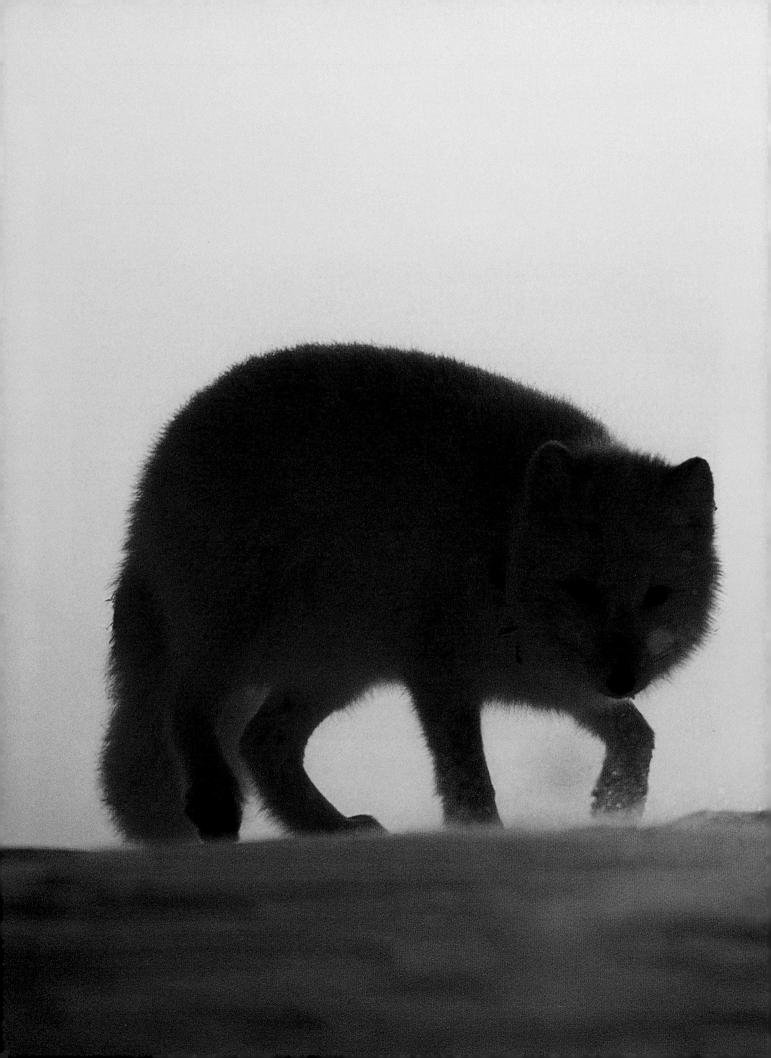

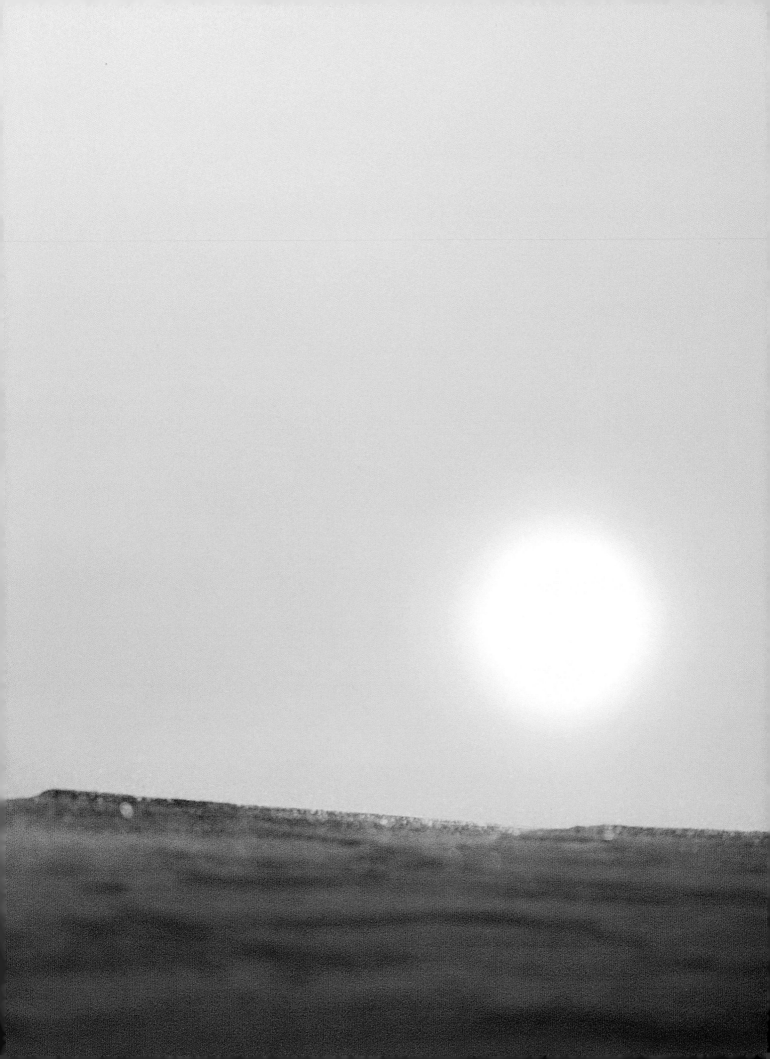

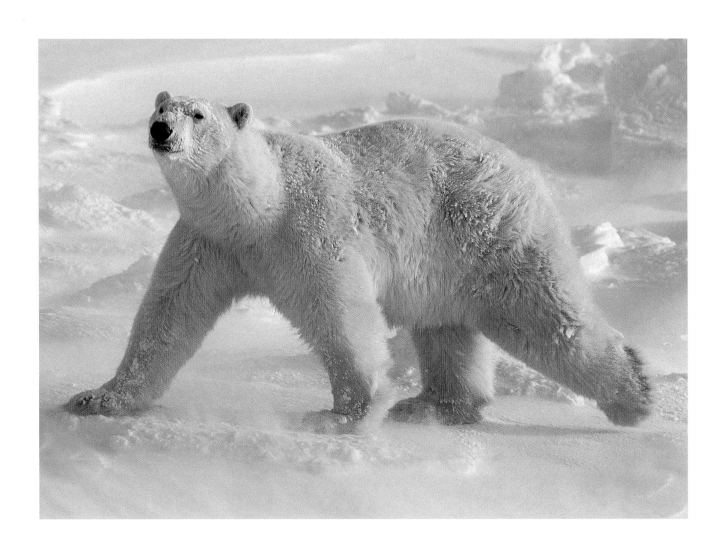

▲ Polar bear fur varies from white to almost yellow. Yellow summer fur results from oxidation; yellow winter fur is stained by seal oil. The individual hairs are actually hollow and clear; they only look white because of the scattering of the visible light. ► Long, dense fur gives the arctic fox an appearance of being well fed and robust. Beneath the fox's voluminous coat is a puny, malnourished frame. If a fox happens to find a bearded seal that has been killed by a polar bear, both the fox and the polar bear may feast.

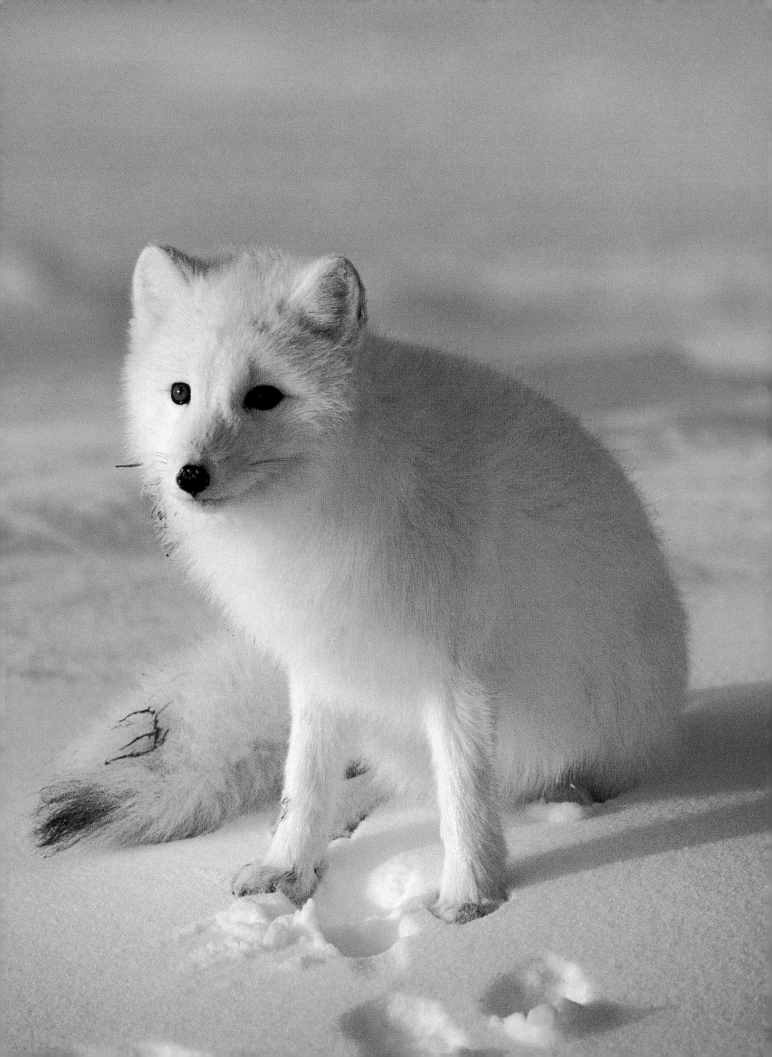

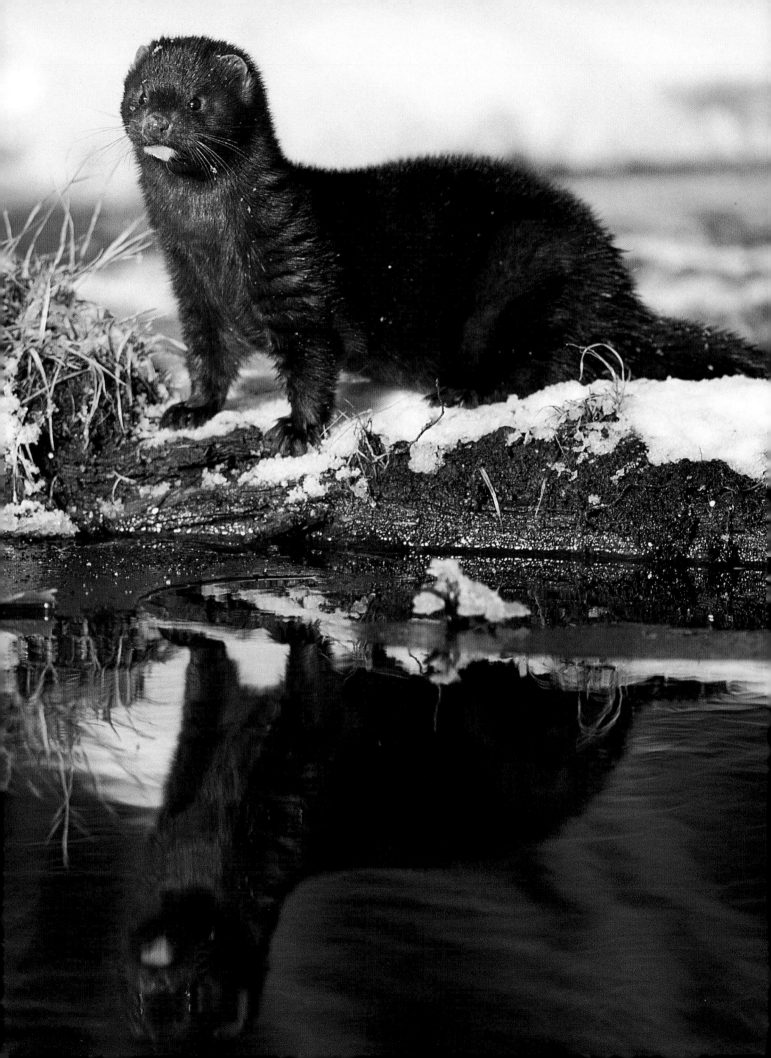

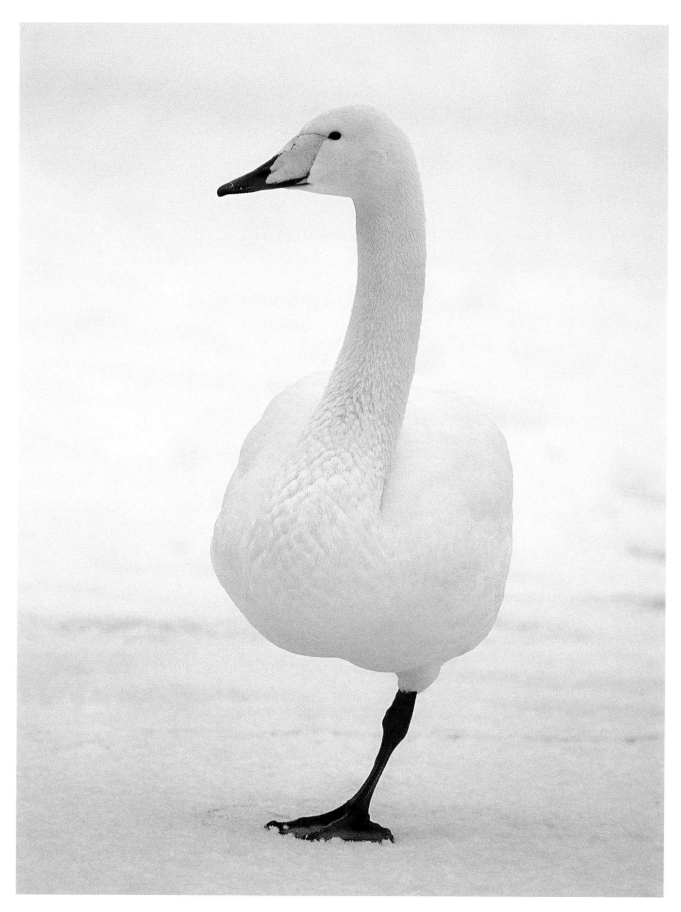

◄ *Mink, weighing five pounds or less, are smaller cousins of land and sea otters.*
▲ *Whooper swans are described as European counterparts of trumpeter swans.*
However, the bill of the whooper swan is almost all yellow.

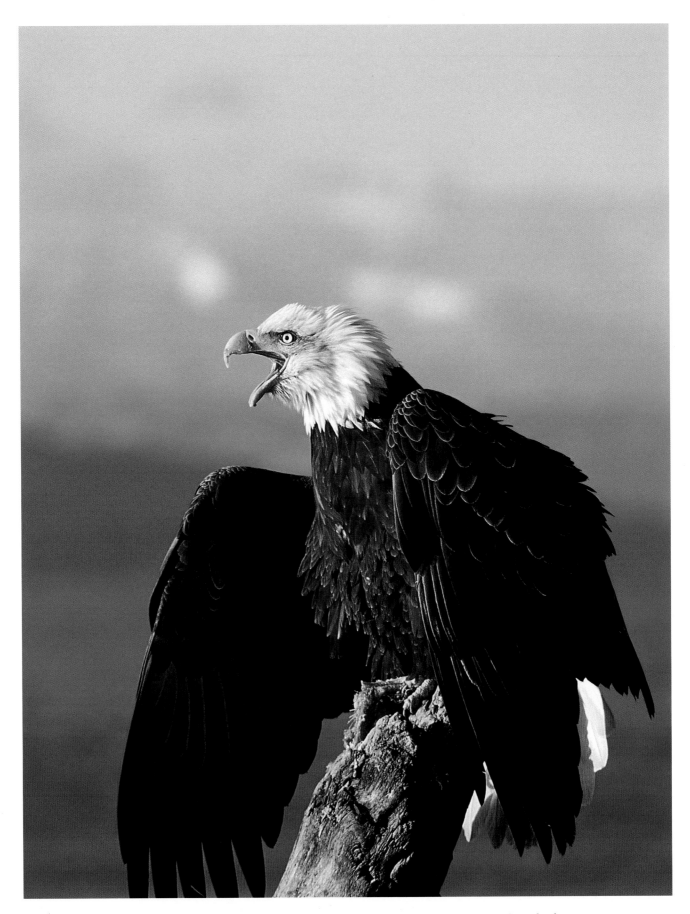

▲ *Eagles may weigh ten to fourteen pounds; their wings span seven to eight feet.*
▶ *A moose forages for willows on a ridge overlooking Kachemak Bay.* ▶ ▶ *Female humpback whales average twenty-five tons; males, thirty-five tons. Males are singers.*

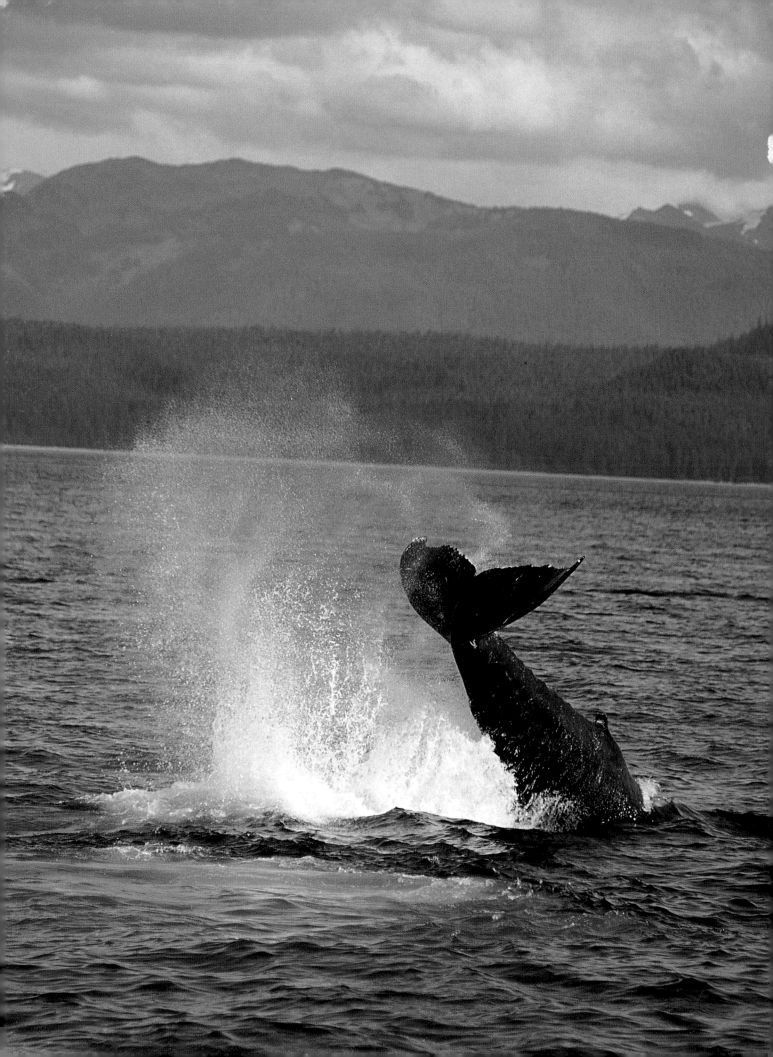